The Invented Eye

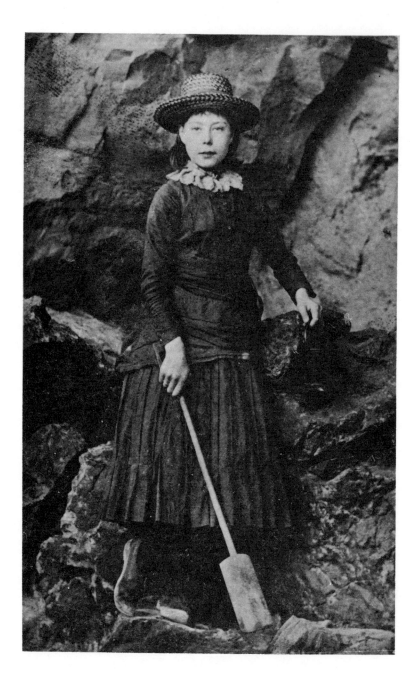

The Invented Eye

MASTERPIECES OF PHOTOGRAPHY, 1839-1914

EDWARD LUCIE-SMITH

PADDINGTON PRESS LTD

THE TWO CONTINENTS
PUBLISHING GROUP

Lucie-Smith, Edward.
 The invented eye.

 1. Photography, Artistic. I. Title.
TR652.L8 770 74-15919
ISBN 0-8467-0040-9
LIBRARY OF CONGRESS CATALOG CARD NUMBER 74-15919
© Copyright 1975 Paddington Press Ltd.
Printed in the U.S.A.

Designed by RICHARD BROWNER

IN THE UNITED STATES

PADDINGTON PRESS LTD
TWO CONTINENTS PUBLISHING GROUP
30 East 42nd Street
New York City, N.Y. 10017

IN THE UNITED KINGDOM

PADDINGTON PRESS LTD
1 Wardour Street
London W1

IN CANADA

distributed by
RANDOM HOUSE OF CANADA LTD
370 Alliance Avenue
Toronto, Ontario

Contents

The Invented Eye

THIS BOOK IS CALLED "THE INVENTED EYE" BECAUSE the camera presented men with a new way of seeing the world. The invention of photography changed men's attitude toward what they saw, and changed it in a fundamental manner. For the first time it was possible to bring time itself to a halt, to freeze the stream of moments, to choose one instant and keep it on record forever.

The thing that fascinated the contemporary audience, when photography was invented, was the power of the camera to record all aspects of a place or an event simultaneously. The image no longer had to be built up in the laborious fashion with which artists were familiar. It appeared at once, all of a piece, imprinted by the sun's rays upon the sensitive paper.

But there were two other considerations which perhaps escaped the early enthusiasts for photography, but which now seem to be of prime importance. One was the subtle shift of emphasis which the camera enforced, from the physical embodiment of the image to the image itself. Oil-paint, watercolor, chalk upon paper—all of these are media with sensuous qualities of their own. Even the etching or the engraving retains this—we are conscious of the way the plate has been pressed into the yielding paper in order to produce the thing we now see. Despite the seduction of certain photographic print-making processes, notably the calotype and the platinotype, photographs are not really like this. They encourage us to look at what they represent more directly; we concern ourselves with the subject, and not with the way the subject is rendered. Sometimes, indeed, we think of photographs as having a kind of independent reality of their own, and not as being mere representations of reality.

This tendency to focus our attention on the subject itself is related to another characteristic which I find in many photographs —what I can only call their "rawness." The subject appears uncooked and unmasticated. The whole digestive process, whereby visual elements are transformed and subordinated to the purposes of the picture, has not yet taken place; the spectator has to undertake it for himself.

In these circumstances, it may seem that the subtitle of this book—"Masterpieces of Photography, 1839-1914"—begs any number of questions. If the situation is as I have outlined it, how can any photograph be a masterpiece? A masterpiece is something that overtops its surroundings, that possesses a unique authority within its own area. And isn't the digestive process essential to this? Again, masterpieces are recognized, not because a single individual imposes them upon us, but through the operation of a consensus. Thus, it is perfectly possible to speak of the masterpieces of European painting. If you asked a hundred well-informed experts to produce a list of the hundred paintings, ranging in date from the 13th century to the 19th, which seem to surpass all others, no doubt each would differ from the rest in many details. But it would not be surprising to discover a substantial area of agreement. This agreement, in fact, serves as a reassurance that aesthetic values still exist, and are identifiable and definable.

Can one make a similar claim for photography, even for the photography of an epoch now so remote from us as the period 1839 to 1914? As I hope to demonstrate, one of the chief fascinations of photography is the multiplicity of purposes that it serves, and the multiplicity of meanings it encapsulates. It is not too much to claim that the aesthetic impurity of photographs is not a defect, but an important part of their interest. Not only must accident play at least a minor role in the creation of every image, but it is impossible to prevent mixed motives from creeping in. Photography is larger than aesthetics in the way that written language is larger than literature. "Beauty," even using that word in the loosest sense, was far from the minds of some of the men who took the pictures included in this book. They wanted to record the images they encountered for a wide variety of reasons, among which were scientific curiosity, the desire for social reform, the wish to record a fact or a series of facts, and the satisfaction of complex private obsessions. But the photograph is an image and not a description, not an approach to reality but in some sense a

counterfeit of it, and this means that it alters our consciousness as well as adding to our knowledge of what is shown.

If we are to speak, then, of the photographic masterpiece, clearly we must define it in the terms that photography itself imposes. It will be an image which makes a significant alteration in the consciousness of the man who looks at it. The point at which it operates is the interface between the operation of memory and the operation of man's moral sense. And this is something which happens in addition to the immediate purpose which is in the photographer's mind—his need to record an event, serve an obsession or even his impulse to produce an image which seems to him beautiful. We judge the photographic masterpiece by the residue which is left after the primary purpose is served; and, like a murky liquid settling in a glass, the exact texture and amount of this residue may take sometime to become apparent. Here is one reason for concentrating on photography of the pioneer period.

Professor Aaron Scharf, in what is perhaps the best of the books devoted to the relationship between art and photography, distinguishes four periods in the development of photography during the course of the 19th century. The first was the epoch of the daguerreotype and the calotype, the two pioneer photographic processes—the discovery of both was announced almost simultaneously in 1839. As Professor Scharf points out, the images these two processes produced were "as dissimilar as the paintings of Meisonnier and Monet." In the daguerreotype all details were clear, pin sharp. Contemporaries were astonished at the perfection of the image—not merely its tonal consistency, but the magical PLATES 2 & 3 fidelity with which even the smallest details were rendered. The PLATE 11 calotype, on the other hand, gave an effect that was both broader and was, in a sense, far more seductive to artists, to whom it suggested that photography could be not merely the rival of painting, but actually its ally. If the daguerreotype killed off the craft of portrait painting in miniature; the calotype laid the foundations for the naturalistic painting of the mid-century.

8

The second period, roughly spanning the 1860's and 1870's, saw the beginning of specifically photographic types of composition. The snapshot, with its often arbitrary cropping of the image, had a parallel in what Professor Scharf calls the "urban realism of Impressionist painting." Eadweard Muybridge's experiments with photographing animal locomotion revealed that the camera saw varieties of truth which the eye was incapable of perceiving. In the 1880's came a further stage in the technological revolution which has affected photography from the time of its invention to our own day—George Eastman's Kodak put the camera into the hands of the masses. By the 1890's, the beginning of the fourth period, photography was no longer a novelty, but the elite were trying to carve out a niche for it as an established form of artistic expression. One result of this ambition was a fascination with ways of manipulating the image, especially through special methods of printing, in order to bring it as close as possible to traditional graphic art. This tendency, in turn, was already causing a reaction toward the severely disciplined but unmanipulated photograph, still making a claim for parity with the fine arts.

PLATE 124

Those who have taken a serious interest in 19th century photography have concentrated on the intricate pattern of action and reaction, continuing down to our own day, between painting and photography. This concentration has done some disservice to the materials available. A similar disservice has been done even by the Gernsheims, whose *History of Photography, 1825–1914* concentrates on the long series of technical innovations whereby the photograph was transformed. Not nearly enough attention has been paid to the alliance between photography and science, or, rather, the dependency of photography upon the researches and discoveries of scientists. This dependency was important from two points of view. The first and most obvious lay in the continuous enlargement of possibilities: the camera could do more and see more with every decade that passed. But almost equally important was the presumption that this continuous process of development created: the presump-

9

tion that photography was in some sense the bridge between the arts and the sciences, and could never wholly cast its lot in with art because science would always be there to assert a claim.

In this connection it is worth remembering how much photography owes, from the purely technical point of view, to experimenters and inventors who were not true scientists, in the sense that they did not possess any extensive scientific education. For example, neither Daguerre nor Fox Talbot—the inventor of the calotype—was a true scientist. There is a certain irony in the fact that Daguerre's great discovery was announced for him, in a lecture given by the scientist François Arago on 19 August, 1839 PLATE 1 at the Institut de France. Daguerre refused to do the job himself because he had stage fright. And in the circumstances, one can hardly blame him. Despite the magnitude of his discovery, and his certainty that the announcement would meet with instant acclaim (Paris was already buzzing with rumors about it, and that day the lecture theater could have been filled a hundred times over), Daguerre's show-business background made him suspect. After being the most successful scene designer of the time, he had become the proprietor of the Diorama—best described as a species of theatrical entertainment in which the scenery took over from the actors.

Fox Talbot's background was rather different. He was a grandson of the Earl of Ilchester, heir, through his father, to the ravishing Lacock Abbey, and a Liberal Member in the Reform Parliament of 1833. Though not perhaps as rich as has sometimes been made out, Fox Talbot belonged without question to the English establishment. He was also a Fellow of the Royal Society, but this establishes his scientific credentials less firmly than one might suppose, as he owed his election to his accomplishments as a mathematician. His interest in photographic possibilities was part of a private quest.

In October 1833, while making a tour on the continent, Fox Talbot had tried his hand at sketching on the shores of Lake Como, near Bellagio, with the aid of a camera lucida. Even thus aided, he

discovered that his skills as a draughtsman were unequal to the task. Formerly, he had made use of a camera obscura with somewhat greater success. This incident, he remarked,

> led me to reflect on the inimitable beauty of the pictures of Nature's painting which the glass lens of the camera throws upon the paper in its focus—fairy pictures, creations of a moment, and destined as rapidly to fade away. It was during these thoughts that the idea occurred to me—how charming it would be if it were possible to cause these natural images to imprint themselves durably and remain fixed upon the paper!

Different as they were in most other respects, Daguerre and Fox Talbot have something in common, in addition to their somewhat peripheral relationship to the world inhabited by professional scientists. This is the fact that both men thought of photography as a kind of collaboration with nature, a means whereby natural forces could be allowed to speak for themselves, instead of having to filter their message through an individual temperament. The title Fox Talbot chose for his book—*The Pencil of Nature*—implies this attitude very strongly; and one of the striking things about the photographs taken by the inventor himself is their tranquil impersonality. This impersonality is one PLATE 10 of the features that make Fox Talbot's images particularly beautiful to the modern eye.

The feeling that nature herself was waiting to speak, if only the means could be found to allow her to do so, seems to have been very generally shared by Daguerre's and Fox Talbot's contemporaries. The fires of Romanticism were dying down, and the new impulse was toward a species of scientific naturalism. The moment it became practicable, photography was seen as the justification of attitudes that many people had already started to profess. Unlike most discoveries of fundamental importance, it was therefore instantly the rage. An eyewitness gives a lively account of the heady atmosphere in which Arago's announcement of Daguerre's method was made. Unable to get into the meeting

itself, he formed part of the dense throng that waited outside.

Gradually I managed to push through the crowd and attached myself to a group near the meeting-place, who seemed to be scientists. Here I felt myself at last closer to events, both spiritually and physically. After a long wait, a door opens in the background and the first of the audience to come out rush into the vestibule. "Silver iodide," cries one. "Quicksilver!" shouts another, while a third maintains that hyposulphite of soda is the name of the secret substance. Everyone pricks his ears, but nobody understands anything. Dense circles form round single speakers, and the crowd surges forward in order to snatch bits of news here and there. At length our group too manages to catch hold of the coattails of one of the lucky audience and make him speak out. Thus the secret gradually unfolds, but, for a long time still, the excited crowd mills to and fro under the arcades of the Institute, and on the Pont des Arts, before it can make up its mind to return to everyday things.

This initial enthusiasm was to sustain itself without difficulty — the daguerreotype rapidly became a runaway success in both Europe and America, and a great deal of easy money was made by those who became practitioners of the new art.

The daguerreotype undoubtedly owed its commercial success to a reduction in exposure time which allowed it to be used for portraiture. At first exposures using Daguerre's process had been three or four minutes even in full sunlight. This improvement was not long in coming, and it immediately yoked photography to the social dynamic of the time. The industrial revolution had been transforming Europe and Great Britain since the middle of the 18th century, and had been duly transplanted to the United States. With the industrial revolution, the middle classes experienced a rapid expansion, as well as an upsurge in prosperity and power. Every new, or newly powerful, class tries to ape the established customs of its betters; and the portrait had become an im-

portant symbol. To have one's portrait painted, life-size or in miniature, implied that one was of sufficient importance for other people to take an interest in one's appearance. In addition to this, the second quarter of the 19th century was a sentimental age, an age in which keepsakes and remembrances were more important, as part of the traffic of social and amorous exchange, than they had ever been before. And lastly, it was an age which took a great interest in human individuality, which believed in the value of the individual, as well as in his simple right to assert himself. The daguerreotype was a providential discovery—it became the means whereby the new class immortalized itself.

When we look at daguerreotypes today, we tend to single out the exceptions—C. F. Stelzner's striking portrait of the family PLATE 6 vegetable woman; the portrait of Laura Bridgman, blind and deaf-mute, by the American daguerreotypists Southworth and Hawes. These moving images show the very best of which the new medium was capable. But the norm was somewhat different. What looks out at us from the average daguerreotype is the middle-class face of the time—sometimes depicted with delicate sympathy, as in the best daguerreotypes by Antoine Claudet—but nevertheless representative of a particular epoch and a particular stratum of society. When we try to deal with material of this kind, to classify it and make a judgment upon it, we are immediately confronted with one of the most obvious characteristics of the camera—its terrible copiousness. Each image it produces tends to be devalued by the existence of numerous similar images. It needs a keen eye to distinguish between the good and the almost-good, especially where no failure of technique is in question.

In the eyes of posterity, the daguerreotype has also suffered because it became the medium of the professionals, and it was the business of the professional photographer to produce what the customer wanted. The calotype, on the other hand, which established itself more slowly, became par excellence the medium of expression chosen by the gifted amateur, which is why calotypes tend to seem so much more fascinating than daguerreotypes when

we look at them today. It is not only that we know them to be the direct ancestors of the photographs we now take ourselves (whereas the daguerreotype remained, from the technical point of view, a dead end), but the subject-matter itself tends to be a great deal more varied and more fascinating.

The reason that the calotype was slow to establish itself lay in regard to patents. The daguerreotype itself was not wholly free of patent restrictions, at least not in England. Though the announced purpose of the French government in taking over Daguerre's invention was to make the process public property, a patent was nevertheless taken out in England some weeks in advance of the official announcement of the discovery. But this, in the circumstances, had little moral authority. It soon gave rise to litigation—the first lawsuit concerning photography followed within three months of Arago's historic lecture. Daguerre's legal rights were much flouted, much disputed, and proved in the end almost impossible to enforce.

Fox Talbot made no pretense of giving his invention freely to the world. He protected the calotype with a series of four patents taken out between 1841 and 1851. Fox Talbot jealously guarded his rights, and his attitudes were greatly but helplessly resented. He became the subject of a number of journalistic attacks. The *Imperial Journal of Art,* for example, said that "Mr. Talbot. . . has exhibited a grasping spirit of monopoly which seems to show that he is animated by motives other than those of a disinterested regard for the promotion of science and the arts." Feelings of frustration became so intense that, in July 1852, the Presidents of the Royal Society and the Royal Academy addressed a joint letter to Fox Talbot in which they appealed to him to make some relaxation of his rights. He was forced to bow to the pressure they put on him, and announced that he would allow the free use of his process except for professional portraiture. The brief golden age of the calotype began.

A historical accident, however, had already enabled the calotype to make rapid progress in one part of the British Isles. This

was Scotland. Fox Talbot did not seek to extend his patent there, believing that it would not be worth his while. This decision offered an opportunity, magnificently taken, to a painter called David Octavius Hill, who was already sufficiently established in his profession to be Secretary of the Royal Scottish Academy. In 1843 Hill was offered an important but daunting commission. He was asked to paint a canvas showing the signing of the Act of Separation and Deed of Demission at the First General Assembly of the Free Church of Scotland, which had been held in May of the same year. When completed (it took Hill from 1843 to 1866 to finish it) this painting contained 470 portraits.

Sir David Brewster—a friend of Fox Talbot—suggested to Hill that the new art of photography could assist him in his gargantuan task. He put Hill in touch with a young chemist called Robert Adamson, who already knew how to use the calotype process. The brief alliance between Hill and Adamson produced a series of strikingly beautiful images, many of them quite unconnected with the original project.

The Hill/Adamson collaboration is full of mysteries, some major and some minor. The most puzzling of all, of course, is the exact nature of the contribution made by each of the partners. Hill was initially given all the credit by his contemporaries; and, in addition to this, he asserted that he had the 'direction' of the photographs, while Adamson was responsible for making the negatives and prints. When the results of their labors were exhibited at the Royal Scottish Academy, they were described as being "executed by R. Adamson under the artistic direction of D. O. Hill." Yet Adamson must have contributed something other than mere technical expertise, as the images Hill produced when working with another photographer named McGlashan, a number of years later, are less striking than the products of the original collaboration.

Part of the magic of the Hill/Adamson calotypes is to be found in their response to the technical limitations which the medium imposed. Chiefly, it enforced a discipline of simplicity—poses had PLATE 12 15

to be simple and static, and it was impossible to make complicated compositions involving numerous figures. In addition to this, the paper negative tended to put the emphasis on mass and tone rather than upon fine detail. Hill himself seems to have been perfectly aware of this—he remarked that what gave the pictures life was that "they look like the imperfect work of man . . . and not the perfect work of God." Clearly, he meant to stress the contrast here with what seemed to many the inhuman perfection of the daguerreotype—often, as contemporary caricaturists pointed out, a perfection of ugliness where portraits were concerned.

The names of Hill and Adamson are now chiefly associated with photographs of two basic kinds of subjects—portraits of friends, relatives, colleagues and a few visiting dignitaries; and picturesque "documentary" photographs, often of Newhaven fisherfolk. But their output was somewhat more various than this might suggest. They also made a small number of beautiful landscape photographs, and at least one highly successful "action" picture, of the Gordon Highlanders at Edinburgh Castle.

PLATE 13

PLATE 11

PLATE 14

It has been remarked of Hill and Adamson, in support of their claim to be among the earliest masters of a new medium, that "they took an infant medium, grasped at once its virtues and limitations and made it their own. Where others had played with photography as a toy they were able to draw it into the mainstream of artistic expression. The calotype was simply another way to make pictures; and the executants were not to know of the years to come in which photography, by proliferation, would seem almost deliberately to debase itself." To the detached observer, this statement would seem to beg quite a number of different questions. The first and most important of these is, of course, the relationship not only between the Hill/Adamson photographs and David Octavius Hill's own painting, but the relationship between these images and the painting which the British school was producing at the same time.

If Hill and Adamson are pre-eminent as photographers, Hill was far from attaining the same eminence as a painter. He and his

collaborator achieved something with the camera that he could not, using the more traditional medium, achieve alone. And yet there is, of course, a connection with contemporary painting—in the circumstances, how could it be otherwise? Yet the difference between these photographs and the kind of art they occasionally resemble is more important than the resemblance. We can see this difference when we look at those photographic images by Hill and Adamson which come closest, at least in subject, to the kind of painting being done contemporaneously. These are, in particular, the long series of photographs of fisherfolk, seen singly and in groups.

The comparison is in some respects not as exact as one would like. From an artistic point of view, the 1840's were years of confusion. They represent the period of transition between Romantic and Victorian art. For this reason, it is difficult to name any single artist, much less a group of artists, as being typical of the age. The names which come to mind, however, undoubtedly include those of Landseer and of Clarkson Stanfield. Turner was still at work (he did not die until 1851), but had isolated himself almost completely from other artists. Wilkie was only recently dead—in 1841. And Etty, that almost-masterly painter of luscious female nudes, was still on the scene. (Indeed, Hill and Adamson took a photograph of him, which he afterwards used as the basis for a self-portrait.) At first glance, none of these painters seems to have much in common with the kind of calotypes which the collaborators were turning out.

Gradually, however, one begins to realize that the photographs of fisherfolk are more disciplined and tranquil versions of subjects that had already appeared in the painting of some of the leading Romantic masters. I once possessed a study by Constable of a fisher-boy on Brighton beach which has a distinct kinship to some of the Hill/Adamson photographs of young fishermen. There is a rather similar Constable watercolor of a fishergirl in the Victoria and Albert Museum. The quality that makes the similarity seem striking, especially at a second glance, is the feeling

of human sympathy. In view of the laboriousness of the photographic process they employed, and also of its novelty, one is surprised to find that the fisherfolk in the Hill/Adamson photographs often have an air of total unselfconsciousness. And the photographers respond to this candor with a wonderful simplicity and openness. If these have claims to be finer images than most contemporary artists were producing, it is because they give us the feeling that the camera has pierced the carapace of artistic convention—not by presenting the figures in strikingly original poses, nor by the use of novel compositional formulae, but by seeing the subjects as individuals and not as types. The comparison that springs to mind is with some of the figure studies painted by Corot. One or two of the best of these are contemporary with Hill and Adamson's collaborative activity, though it is unlikely that the two Scotsmen can have known them.

The Hill/Adamson calotypes raise two issues which appear in somewhat different form later in this book. One is the question of collaboration. Is photography a medium that welcomes this, where traditional forms of fine art seem to reject it? Another example of successful collaboration is to be found in the photographs which Gardner and others took during the American Civil War; and one can cite, too, the partnership of Robertson and Beato in the Crimea and in India, as well as numerous instances of successful business partnerships, such as that of Southworth and Hawes in Boston. The other question is that of the contribution made to photography by men who received their initial training in art of a more traditional kind. A glance at the biographies at the back of this book will reveal numerous instances.

But instead of pursuing these issues—chiefly because the answers seem in fact to be obvious—it seems more profitable to continue from Hill and Adamson to the work of two other British photographers, who are also among the most celebrated early practitioners of the art. Both are exceptional in more than one way.

Lewis Carroll and Julia Margaret Cameron were both amateurs,

18

though this was a status which each showed some disposition to shake off. Mrs. Cameron put her prints on sale through Colnaghi's, the celebrated Bond Street art dealers. Carroll sold some of his prints through Ryman's, the fine art dealers in Oxford, and occasionally parted with the copyright of a negative. His photographs of Tennyson and of D. G. Rossetti, for example, were published commercially. Both Carroll and Mrs. Cameron had a wide acquaintanceship among the literary and artistic celebrities of their time, and have left us telling portraits of their famous contemporaries. At this point, the resemblances stop.

PLATE 18

Carroll, or to give him his proper name, the Rev. Charles Lutwidge Dodgson, was one of the strangest of eminent Victorians. His celebrity as the author of the *Alice* books will probably never be rivaled by his reputation as a photographer; but he was, for all that, one of the greatest photographers of his time. And his camera was often put at the service of the same obsession which provided him with the inspiration for *Alice*.

Carroll first encountered photography in the summer of 1855. He was introduced to it by his favorite uncle, Skeffington Lutwidge, and it took an immediate hold on his imagination. In September 1855, he used the phenomenon of the latent image as the inspiration for a fantasy called *Photography Extraordinary*, in which the camera is used to record, not the appearance, but the thoughts of a vapid young man. Successive stages of development turn an anecdote of the "milk-and-water school," present in the young man's mind, into something forceful and splendidly melodramatic.

In March 1856, Carroll ordered his own photographic outfit, choosing the newer collodion process over the calotype one to which his uncle had introduced him. It was an inspired decision, for Carroll almost immediately began to make great strides with his hobby. In early June, he recorded in his diary: "Spent the morning at the Deanery, photographing the children." The PLATE 15 Deanery was the residence of Dean Liddell, the classical scholar who is still remembered for the famous lexicon known to genera-

tions of schoolboys as "Liddell and Scott." Among the children was his daughter Alice, then aged four, for whom the famous stories were to be written. The Dean, like Carroll himself, formed part of the academic community at Christ Church, the largest and, some would say, the grandest of Oxford colleges. It even has Oxford cathedral for its chapel.

Children, and more particularly little girls, were to be one of the two dominant themes of Carroll's photographs. The other was to be the pursuit of celebrities—a matter about which he could be almost as ruthless as his rival Mrs. Cameron. He tried to get the Prince of Wales when the latter came as a student to Christ Church in 1859, and was rather humiliatingly refused. He also tried hard to get a picture of the painter G. F. Watts, a great friend of Mrs. Cameron's. Here, too, he did not succeed. The tone in which he describes a visit to the lady herself—the description comes from a letter to his sister Louisa—reveals how galling this refusal probably was to him:

> In the evening Mrs. Cameron and I had a mutual exhibition of photographs. Hers are all taken purposely out of focus—some are very picturesque—some merely hideous —however, she talks of them as if they were triumphs in art. *She* wished she could have had some of *my* subjects to do *out* of focus—and *I* expressed an analogous wish with regard to some of *her* subjects.

Eloquent as many of Carroll's portraits of the famous are—the Rossetti, for example, has certainly helped to form our image of the painter's appearance—they are surpassed by the pictures of what Carroll called his "child friends." The obsession with children, and especially with pre-pubescent girls, was something that Carroll shared with many of his 19th century contemporaries. (It finds vivid expression, for instance, in Kilvert's *Diary*.) Often the interest was frankly sexual, and this, too, has left its traces in surviving photographs. Graham Ovenden and Robert Melville, in their book *Victorian Children*, reproduce a number of nudes in which the subjects are very young girls. The poses and expres-

sions leave no doubt that the purpose of these photographs was far from innocent.

Carroll's photographs are not like this, though he did take some pictures of nude girls which are now unknown to us because they were returned to the sitters after the photographer's death and presumably destroyed. No doubt the sexual drive which was the mainspring of his interest was largely hidden from him, though we know that, at one point, he entertained the fantasy that he might marry Alice Liddell. But the camera responds to the intensity of his interest. The children he photographed are penetratingly seen. Often they have a somewhat abstracted air, as in the portrait of Grace Denman, the daughter of Lord Chief Justice Denman. At other times, the sitter's expression implies a close relationship with the photographer himself. A good example of this is the picture which Carroll entitled *"It won't come smooth,"* PLATE 16 a portrait of Irene MacDonald, whose father was George MacDonald, the Scottish novelist and poet. Here the sitter's despairing look is an appeal to someone she knows will understand her predicament. It is quite different from the awful scowls which we sometimes find on the faces of Julia Margaret Cameron's child sitters. Their expressions seem simply to reflect the agony of having to remain still for so long.

It is also worth making a comparison between Carroll's photographs of children and those made by the professional photographer O. G. Rejlander. Rejlander made his reputation with a vast "composition" picture, made by using over thirty negatives, which he first called *Hope in Repentance*, and, later *The Two Ways of Life*. Later, he reacted against this artificial way of working, and some of his best photographs are of London street PLATE 19 urchins. It was this aspect of his work which interested Carroll, and it may well be that Rejlander was an important influence on Carroll's work. Carroll, for instance, kept a stock of costumes, including some picturesquely ragged ones in which his middle- PLATE 17 class sitters could pose as beggar-children.

Rejlander's pictures have great charm. But they are neverthe-

less somewhat artificial, molded by preconceptions which the photographer has brought to his subject matter. The urchins we see in them are genuine enough: Rejlander got his sitters from the local Boys' Home near his London studio, and was therefore asking them to re-assume the role from which they had been rescued. But it was he who posed them, and it is clear that what he had at the back of his mind was the conventional romantic view of the street arab, so typical of Victorian evasiveness about both childhood and poverty. Carroll may occasionally put his sitters into fancy dress, but he invites their collaboration in the enterprise in a way that Rejlander does not. He was famously good with the very young, and we can see it in his photographs.

But the satisfaction that he himself derived from the work clearly went much further than the rapport he achieved with the children who sat for him. He had discovered one of the unique qualities of the camera: its ability to call a halt to time. He was one of the earliest to locate this characteristic so precisely. The sadness of his relationships with his "child friends" was that they were bound to grow up. But, by taking a photograph, Carroll could call a halt to this inexorable process, and could record the moment of happiness when it occurred.

Julia Margaret Cameron, Carroll's acquaintance and rival, is in some ways a yet more extraordinary figure than he is. She took photography much more seriously than he did, and she has been rewarded by being elevated, in our own day, to the position of Victorian photographer *par excellence*. Quite recently, an album of her photographs fetched no less than £52,000 at auction—a tribute Mrs. Cameron herself would certainly have relished. She tended to feel, as Carroll hints in his description of a visit to her, that not nearly enough credit was given to her merits as an artist.

It would be unwise, however, to think that Julia Margaret Cameron was in any way typical of 19th century photography in general. Indeed, every comparison seems to demonstrate that she was an exceptional individual—in many respects even more exceptional than her contemporaries thought her.

22

Not the least remarkable thing about her was the fact that she was a woman. Just as Carroll instinctively sensed that photography was the heaven-sent means of mitigating the tragedy of his obsession with childhood, so, too, Cameron found (though perhaps without formulating the matter in her own mind) that the newly-invented art of photography provided an outlet for feminine energy and feminine creativity. In the older arts, women were assigned an inferior position. If they achieved any professional success, it was regarded as a kind of miracle. Photography was too new for such prejudices. Only the art of novel writing had so far offered an equivalent outlet, and this was *par excellence* an art which could be practiced at home. Photography, on the other hand, brought the practitioner into direct contact with reality.

Julia Margaret Cameron was by far the ugliest, certainly the most eccentric, but also the most gifted of a remarkable family. Her self-confidence (a marked trait in her character) sprang at least in part from her background. Her maiden name was Pattle, her father was in the service of the East India Company, and she was born in India in 1815. Shortly after her marriage in 1838, her husband, Charles Hay Cameron, replaced Thomas Babington Macaulay as chief of the India Law Commission. While they remained in India, Mrs. Cameron occupied an unchallengeable social position. Then, ten years after their marriage, the couple returned to live in England.

Mrs. Cameron, a woman of immense energy, soon surrounded herself with all the celebrities of the time. A period at Tunbridge Wells brought her the friendship of Henry Taylor, author of the widely praised poetic drama *Phillip van Artevelde*. Later the Camerons moved to East Sheen, and their house was soon full of famous men. Tennyson became a close friend, and so too did PLATE 26 Thackeray, the sculptor Thomas Woolner, and the poet Aubrey de Vere. A frequent visitor was the great astronomer Sir John PLATE 27 Herschel, whom the Camerons had known previously in Capetown. Cameron's sister Sara, married to Thoby Prinsep, once an official in the East India Company, held court at Little Holland

House in Kensington, where she was mistress of one of the most agreeable of mid-Victorian *salons*. And with the Prinseps lived the painter George Frederick Watts.

In 1859, Charles Cameron decided to pay a visit to the East in order to visit a coffee estate he owned in Ceylon. His wife remained behind in England and discovered that she missed her husband a great deal. She needed distractions, and soon found them. The Camerons had been planning to leave East Sheen to go and live near Tennyson on the Isle of Wight. Mrs. Cameron flung herself into accomplishing this project. Early in 1860, a new house was chosen (it was, in fact, a pair of cottages), and the business of converting it was put in hand. But even the move was not enough to stave off melancholia. Hoping to give her a new amusement, Mrs. Cameron's daughter Julia presented her mother with a photographic outfit. In this fortuitous fashion, her career as a photographer began.

At first, her progress was slow. An intricate series of manipulations was required, and Mrs. Cameron was not naturally dextrous. She was, however, persistent, and determined to get results. She did not mind how many negatives she spoiled. And once she had mastered the process, her innate forcefulness and originality triumphed.

Her originality took different guises. Despite her taste for celebrities, Mrs. Cameron burst through the social barriers of the time in a way that was disconcerting to her contemporaries. She had a beautiful parlor-maid, whom she posed so many times for religious compositions that the household nicknamed the girl "Mary Madonna." If she saw an ancient laborer passing by on the other side of her garden hedge, Mrs. Cameron would set off in pursuit of him: he was the very person she needed to represent Father Time.

More important from our point of view is the technical originality of Mrs. Cameron's photographs. She used very large negatives (these necessitated long exposures, which were often a severe trial to the sitters) and she specialized in out-of-focus effects. She

seems to have arrived at these effects by a process of trial and error. When focusing the lens she would stop, not when perfect sharpness was reached, but when she found an effect that pleased her. Her whole endeavor in making portraits was, as she said, to record faithfully "the greatness of the inner as well as the features of the outer man." A true Victorian, she was a born hero-worshipper. But she also clung to a kind of photographic purism. She trusted the camera's vision, and refused to retouch her work. To this point of principle she added a cavalier disregard for technical perfection. All of this tended to shock the professional photographers of her own epoch. She drew a long complaint, for example, from the highly successful H. P. Robinson. Some of her photographs, he said, possessed

PLATE 57

> so little definition that it is difficult to make out parts even in the lights; in the shadows it often happens that nothing exists but black paper; so little care whether the sitter moved or not during the enormous exposure, which, I have been told, was given to these pictures, that prints were exhibited containing so many images that the most careless operator would have effaced the negative as soon as visible under the developer; and, apparently, so much contempt for what we may call the proprieties of photography, that impressions from negatives scratched and stained, and from which, in one or two cases, the film had been partly torn away, were exhibited as triumphs of art. The arguments of the admirers of these productions were that the excellencies existed because of the faults, and that if they were in focus, or more carefully executed, their merits would be less.

Basically, Mrs. Cameron's work falls into two categories—portraits and fancy pictures. The former are chiefly of eminent contemporaries (Mrs. Cameron had little time for commonplace people), while many of the latter are photographic illustrations to Tennyson's *Idylls of the King*, or else religious compositions. In the portraits as much as in the fancy pictures, Mrs. Cameron

PLATE 25

shows a debt to painting. She was eclectic in her influences. The Madonnas, for example, clearly show a debt to Raphael—the Victorians enormously admired the rather sentimental simplicity of compositions like the *Madonna della Sedia*, and it is the sentimentality that Cameron catches and exaggerates. On the other hand, the Tennyson illustrations are directly comparable to the work of the English Pre-Raphaelite painters, her contemporaries. It has often been remarked that Pre-Raphaelite work in the medieval style has, for all its vaunted accuracy of detail, an unmistakably Victorian look. This is something which the camera makes comic. These medieval kings and queens are all playing charades, and their impersonations have the precariousness which we all remember from taking part in party games of this type. Charles Cameron, pressed into service to play Merlin, is reported to have spoiled the photograph by starting to giggle. As for the portraits, the artist to whom they owe most is undoubtedly Watts.

As it happens, Mrs. Cameron is one of the few Victorian photographers to have been made the subject of an appreciation by a distinguished art critic. The critic was Roger Fry, and his interest in her work probably originated in the fact that Virginia Woolf was the granddaughter of Maria Jackson, another of the Pattle sisters. By blood, therefore, she was closely connected to the tribe of Bloomsbury; and the relationship was enough to excuse a touch of the Victorian high seriousness which Bloomsbury detested.

Fry has no doubt about the aesthetic merits of the best of Mrs. Cameron's work. "Let there be no mistake about it," he says, "the unique record of a whole period which these plates comprise is not due merely to the existence of the camera, it is far more due to the eye of the artist who directed and focused it. And Mrs. Cameron had a wonderful perception of character as it is expressed in form, and of form as it is revealed or hidden by the incidence of light." Indeed, the critic concludes by hinting that Cameron's photographs have led him to reconsider some elements of his critical

position. He foresees that "manual skill in pictorial art" will grow increasingly less important.

> With the inevitable growth of mechanical processes in the modern world we shall probably become increasingly able to concentrate our attention on those elements of artistic expression which do not depend upon this intimate contact at every point of the work with the artist's nervous control, and to disregard those particular qualities in the work which depend exclusively on that. Other qualities undoubtedly remain, such, for instance, as the general organization of the forms within a given rectangle, the balance of movements throughout the whole structure, the incidence, intensity and quality of the light. In short, all those elements of a picture which we may sum up in the word composition are to some extent independent of the exact texture at each point.

These opinions are doubly striking because they do not imply any abandonment of Fry's basic doctrine of "significant form." He believed that in all painting the forms are paramount—that even in representational art it is the relationship of these forms which dictates our response at its deepest and most serious level. Fry was willing to try to extend this doctrine into a new realm, that of the photograph. Of course, he sees that, from his point of view, one of the drawbacks of the medium is its occasional over-particularity, even in the work done by Mrs. Cameron. Speaking of one of her Madonna compositions, he notes that, had it been the work of a painter, "the rhythm of the drapery would have been more completely brought out by slight amplifications and retrenchments there, by a greater variety and consistency of accents, and by certain obliterations." But he notes, too, that Mrs. Cameron's sitters "abound in the sense of their own personalities," and that this was a quality which the camera, in her hands, was uniquely fitted to convey.

In fact, Fry seems slightly to misread Cameron's work by missing the significance of the quality of photographic rawness

PLATE 22

which I mentioned at the beginning. It is informative, when thinking of this, to compare Pre-Raphaelite paintings, not only with Mrs. Cameron's imitations of them, but with Rossetti's photographs of Jane Morris. These photographs were obviously intended to serve as studies for painting; they are not, therefore, "complete" in the sense that Mrs. Cameron's images are complete. But one cannot help being struck by the difference between the photographic images and the paintings to which they relate. The beautiful Jane Morris looks frowsty and crumpled; her hair is frizzy and coarse; her features are sullen. It is like seeing the face behind the mask. Yet Rossetti's photographs have an integrity of their own, in what they tell us about his obsession with Jane Morris herself. In this sense they are directly comparable to the beautiful drawings of Lizzie Siddall which he made earlier.

Where Fry was right was in putting the emphasis on Mrs. Cameron's portraits, as opposed to the rest of what she produced. If her fancy pieces are inferior to Pre-Raphaelite painting, the portraits usually seem greatly superior to those painted by Mrs. Cameron's beloved Watts—though it seems likely that, despite her desire for recognition, she herself would have been outraged by such a judgement. It is difficult, now, to realize just how high Watts's reputation rose among his contemporaries. At the period of Mrs. Cameron's photographic activity it had not as yet reached its zenith; that was to come at the end of the painter's life, and he did not die until 1904. In a book about Watts published in that year, G. K. Chesterton claimed that he, "more than any other modern man, and much more than politicians who thundered on platforms or financiers who captured continents . . . has sought in the midst of his quiet and hidden life to mirror his age." One of the ways in which he mirrored it was in making portraits of his celebrated contemporaries.

Watts's technique does not have the sharp glitter of Pre-Raphaelite painting. His major influences were Titian and the other great Venetians of the 16th century. Like them, he sought to envelop his forms in a warm opalescent haze—though this

technical preference appears in its most exaggerated form not in Watts's portraits but in his ambitious allegories. It may have been Watts's haziness which encouraged Mrs. Cameron to look more closely at the possibilities offered by soft-focus effects when accident first led her to them.

Yet despite the immeasurable advantage of color, Watts's portraits are rarely as striking as the best of Mrs. Cameron's. The reason that she triumphs over him is quite simple—Fry had already put his finger on it. In addition to being a lion-hunter and a somewhat overwhelming and dictatorial friend, she was passionately interested in people. The camera, in her hands, became not only a mechanical means of producing pictures, but an instrument of character-analysis. Presented as she presents them, her sitters cannot hide their true natures. They are forced to speak out.

Mrs. Cameron is not the only 19th century portrait photographer to possess this gift. Two Frenchmen, Etienne Carjat and Nadar, possessed it to almost the same degree, and have left us as striking a gallery of celebrated Frenchmen as Mrs. Cameron did of famous Englishmen. Though both men made portraits professionally, photography was only a small part of their activity. Carjat was many things: editor, journalist and caricaturist. Nadar was perhaps even more of a jack-of-all-trades. In addition to writing and making caricatures, he was an enthusiastic balloonist, and made use of the opportunities the balloon offered him in order to take the first aerial photographs.

In this connection, however, the thing that matters is that Carjat and Nadar, before they took to the camera, were both skilled in caricature. If we look at Carjat's portrait of the composer Rossini, for example, we are fascinated by the confident PLATE 33 cock of the head, the humorous sparkle in the eyes. In fact, the picture succeeds in bring out what the skilled caricaturist would instinctively look for, as a basis for his humorous exaggerations. Nadar's George Sand is more pensive, more dignified and there- PLATE 30 fore less journalistic. What it does have is immediate impact—the personality comes across at once.

It was through pictures such as these that the best 19th century portrait photographers began to change our concept of portraiture itself. Indeed, it is now almost impossible to recapture precisely what men must have felt when they looked at painted or sculpted portraits before the camera was invented.

A portrait produced by a painter or sculptor is always a synthesis of impressions, and we assume that the artist is attempting a definitive view of the sitter—a verdict. Strong traces of such a desire for a definitive verdict, or at least a synthesis, are still to be found in Julia Margaret Cameron's photographic portraits; perhaps this was the result of the merciless length of her exposures. Contrariwise, when we look at the paintings of a man like John Singer Sargent, created at a moment when the progress of photography was already far advanced, we notice that they often duck the task of giving a "definitive" view of character, however many sittings it took to achieve them. Despite the brilliance of the photographic portraits produced by Carjat and Nadar, we usually sense in them the possibility of other views, other aspects of the sitter. What these portraits have in common with caricatures is nothing so crude as exaggeration, but the quality of revealing personality in a single flash of lightning, of being "impressions" only.

Discussion of Carjat and Nadar makes it opportune, also, to speak of some of the other early photographers working in France, or in a French context. If the work of 19th century photographers in England is often marked by a certain eccentricity, the elegance of their French contemporaries is equally striking. No French photographer, for instance, can convey the strangeness of atmos-PLATES 46, 47, 48 phere to be found in the photographs of Lady Hawarden—women embraced, standing with their backs turned to us, glancing round to see what the photographer is at; or, alternatively, standing alone and gazing into a mirror. On the other hand, no Englishman made pictures as elegant as those which Charles Nègre took at the PLATE 39 Imperial Asylum at Vincennes in 1860. His view of the pharmacy has a discipline rivaling that of Vermeer. Yet curiously enough,

Nègre was a professional painter, and much less considerable in that profession than he was as a photographer.

Equally fine, in their tenderness and melancholy beauty, are the pictures that Gustave Le Gray took of the sea. In this case, the painter they call to mind is Courbet. Yet despite the fact that they are often made from two negatives—one for the sea itself, one for the sky—they convey, more powerfully than any painting can, the conviction that the sea looked thus, at a particular moment, on a particular day.

II

The work of Le Gray, like that of many of his mid-Victorian contemporaries, illustrates the way in which photography brought about a series of subterranean shifts in attitude, and proved that the photograph could do things that were impossible for painting, while at the same time satisfying impulses which could not be satisfied by more traditional means. Not only the number of available images, but also their range was immensely enlarged. The "invented eye" saw more in more senses than one. In doing so, it helped to bring about social changes as well as a change in sensibility.

As soon as photography was invented, people realized its possibilities as a means of recording topography and architecture. The power of the daguerreotype to catch the minutest architectural details was one of the things that fascinated Daguerre's contemporaries. Ruskin was an early admirer of the new art. He tells us in *Praeterita* that: "the plates sent to me in Oxford were certainly the first examples of the sun's drawings that ever were seen in Oxford, and, I believe, the first sent to England." He became an ardent collector of daguerreotypes of French and Italian architecture, as well as of landscape views. His own drawings, too, became increasingly dependent on photographs. "Every chip of stone and stain is there," he wrote, in an enthusiastic letter to his father, "and of course there is no mistake about proportions."

By 1846, however, Ruskin had already begun to react against photography. He grew increasingly determined to make it the handmaid, rather than the mistress of art; and he deplored its emphasis upon tone rather than line. Eventually he came to feel that "the use of instruments for exaggerating the powers of sight necessarily deprives us of the best pleasures of sight."

Ruskin's reaction against the photograph placed him in a minority. The photograph soon came to dominate men's vision of the world, and especially their vision of places unknown to them personally. The passion for travel and for books about travel had grown rapidly throughout the 18th century, and showed no signs of waning during the 19th. The borders of the known world were continually being extended. At the time when photography was born, public attention was focused on North Africa and the Middle East. The initial interest had been aroused by Napoleon's campaign in Egypt, and leading romantic artists such as Delacroix and Chassériau had reinforced it with their glamorized vision of Arab civilization. In France, in the first half of the 19th century, there was a whole school of lesser painters who specialized in oriental scenes. Among them were Alexandre Decamps, Eugène Fromentin (now better remembered for his writings on art), and Alfred Dehondecq. The work of these men was not as personal as that of the true romantics: it was a mixture of the consciously picturesque and the documentary. Reality was served, but it was also carefully edited to make sure it appealed to the taste of the public which annually visited the official Salon.

In the first half of the 19th century, there was also an eager audience for illustrated books which dealt with foreign scenes and subjects. Many of these were handsomely produced and illustrated with lithographs. When the daguerreotype was born, it did not take long for someone to think of pressing it into the service of the travel book. The best-known and most ambitious of these early enterprises was the series of *Excursions Daguerriennes*, which was published in parts during the years 1841–4. One hundred and eleven plates were included, engraved by various artists after

daguerreotypes. Two of the plates were prints made from the actual daguerreotypes themselves, etched by H. Fizeau.

The *Excursions Daguerrienes* were extremely well received, but represented only a first step on the way to replacing lithographs or engravings by photographic illustrations. The disadvantage of the daguerreotype for illustrative purposes was that the process produced a single direct positive, not a negative from which positives could then be taken. This meant that, for the most part, the image had to be re-drawn by an artist before it could appear in a book, and in the process of translation, authenticity was inevitably lost.

Soon the daguerreotype was abandoned for purposes of topographical illustration, and illustrated books began to appear with original photographs. One of the earliest and most splendid of photographic travel books of this type was Maxime du Camp's PLATE 40 *Egypte, Nubie, Paléstine et Syrie*; and it was to be followed by many others. Du Camp's fellow-countryman Désiré Charnay documented Central America and Mexico, and worked in Madagascar, Chile, Java, and finally the Yemen. Among the best-known PLATE 69 British travel-photographers were Francis Frith, who worked in Europe and the Middle East; and John Thomson, who traveled in PLATES 70, 71 Cambodia and in China.

If we look at Du Camp's or Frith's photographs of Ancient Egyptian ruins and monuments, we are struck by their sobriety, almost, one might say, their dullness, when compared to what a lithographer such as David Roberts might have done with the same subjects. But this dullness was what the public wanted. *The Times* said of Frith's photographs that they "carry us far beyond anything that is in the power of the most accomplished artist to transfer to his canvas."

This phrase pinpoints the special power of the medium—its authentification of vicarious experience. The spectator who looks at the picture begins to feel that he has looked, not at a mere representation, but at a real scene. The passion for stereographic views, which swept Victorian drawing rooms, was only a logical

extension of the feeling which is expressed so succinctly in the old cliché—"the camera cannot lie."

The influence exerted by photography on 19th century culture was in large part due to this power of insisting upon the actuality, somewhere and somewhen, of what was to be seen in photographic images. This, in turn, had a further consequence—it brought about the breakdown of long-established visual conventions. The usual procedure of the artist, when confronted with an unfamiliar subject, was to translate it into terms which were more familiar to him, to seek a parallel, not only within the boundaries of his own experience as an individual, but within those of the tradition within which he worked. If the painter had a conflict between what he saw and what he felt he should be seeing, then the ideal vision he had formed invariably triumphed over the evidence of his senses. The camera on the other hand could only report what was actually there, unless the negative or the print were afterwards tampered with.

A good example of what I am talking about can be found in the history of exploration. Hitherto, as European civilization expanded, the explorers had brought with them a way of looking at the known which they imposed upon the unknown. The Tahiti painted by William Hodges, who sailed with Captain Cook, owed a good deal to the way in which Richard Wilson had seen the Roman campagna. Wilson, in turn, had modeled his work upon the ideal landscapes painted by Claude. Try as the photographers might, they could not impose upon their work this consistent degree of stylization. Strange geological forms and, still more, exotic kinds of vegetation, began to dominate the images they made. When we look at Samuel Bourne's view of Upper Burma, PLATE 72 we are aware that an unfamiliar kind of landscape and an unfamiliar climate have thrust themselves upon the lens. The photographer has dealt with them as best he could. Stranger still is a view taken in the New Zealand bush by an English emigrant PLATE 80 photographer, James Bragge. To the eye of someone nurtured on European landscape painting, this still seems an impossible,

almost an outrageous kind of image—a land altogether alien, hostile, and sufficient unto itself.

It was through the camera that people assimilated, and tried to cope with, the immense expansion of their world. Photographs taken in America as the conquest of the West proceeded make this point very vividly—none more so than the pictures taken by Timothy O'Sullivan as he accompanied various U.S. Government PLATES 92, 93, 95 expeditions in the period following the Civil War. From these pictures there breathes a kind of euphoria: not merely the euphoria of discovery, but a sense of space and liberty which makes one conscious of the power of the American dream.

In fact, the West and the frontier produced not one but several different kinds of photography, and it is worth considering what these were. First, there was what we may call the photography of exploration—new places, new scenes, recorded before the hand of civilization had been laid upon them. O'Sullivan produced photographs of this kind. In addition to this, there was a more specific record of Indians and Indian life. Naturally enough, given the current interest in the North American Indian and his tragic fate, much attention has recently been given to material of this kind; and a sustained effort is being made to discover and publish, or republish, whatever images are available. It seems to me, however, that not enough effort has been made to differentiate how changes of attitude towards the Indian can be detected in these photographs.

Indians and Indian life attracted the interest of photographers PLATE 76 relatively early. The Indian was a mystery, and a threatening one at that, and the camera seemed a means of bringing him within the compass of what Europeans could understand. A daguerreotypist called Josiah Gregg is believed to have been busy taking pictures of Indians along the Santa Fe trail as early as 1846. In 1851 the San Francisco-based daguerreotypist Robert H. Vance advertized "a large collection of the different types of Indians on the Pacific Coast" as being among the images he was exhibiting in New York.

The Indians themselves seem to have submitted to the attentions

of these early photographers with something approaching delight. In 1853, Governor I. I. Stevens of Washington Territory reported of the activities of the daguerreotypist who accompanied him to Fort Benton:

> Mr. Stanley commenced taking daguerreotypes of the Indians with his apparatus. They are delighted and astonished to see their likeness produced by the direct action of the sun. They worship the sun and they considered Mr. Stanley was inspired by their divinity and he thus became in their eyes a great medicine man.

A little later, this cooperative attitude was to change. The Indian attitude towards the "shadow-catchers" became one of suspicion, mistrust and fear. Photography was becoming identified with the other evils the white man brought with him. Nevertheless, photographers continued to record the Indian and his way of life, often taking great risks in order to do so. Ridgeway Glover, a young Philadelphian who set off in 1866 to "illustrate the life and character of the wild men of the prairie," was killed by a war-party of Arapaho Indians near Fort Phil Kearney. The Indians cut off Glover's head and mutilated his body.

Among the most fascinating of the pictures taken of American Indians in the period immediately following the Civil War are those by a young man called Will Soule. Soule fought for the Union in the war, and was severely wounded at Antietam. Afterwards he worked as a clerk in Washington, D.C., and then at a photographic gallery in Chambersburg, Pennsylvania. His older brother had already become involved with photography before the outbreak of hostilities, and had set up a business in Boston. In 1867, after the Chambersburg gallery had burned to the ground, Will Soule decided to move westwards, in the hope of recovering his health. He took a complete photographic outfit with him.

PLATES 138, 139, 140 These pictures make an instructive contrast with those taken later on by Edward S. Curtis, the most famous and also perhaps the most gifted photographer to have recorded the Indian tribes. Curtis began work in 1896, nearly thirty years after Soule. His

36

interest in the Indians was all-consuming, and he photographed them over a much longer period: he did not finish his self-appointed task of recording everything he could about them until as late as 1930. One is keenly aware of the immense shift in attitude which even his earliest photographs reveal.

The difference is really that between objectivity and subjectivity. Soule records his subjects almost as if they were natural objects—leaves or shells or stones. Though he must to some extent have won their confidence to photograph them at all, we are conscious of the immense gulf between the man who set up the camera and the man who posed for it. Perhaps unconsciously, Soule stresses the idea of confrontation with an unyielding strangeness. Curtis, on the other hand, makes pictures which are full of emotion. We feel in all his images a sense of doom, a compassion for the tragic fate which had overtaken the Red Man. Yet, at the same time, Curtis is imposing on his subject complex ideas which have nothing to do with Indian culture as such. His work is influenced, like much other photography of the time, by the doctrines of the Symbolist Movement which had its origins in Europe, and these led him to search for archetypes where maybe none existed.

Just as there is a link between Curtis's work and that of Symbolist artists such as Odilon Redon and Fernand Khnopff, so too we can discover links between Soule's portraits of Indians and images which were being made by photographers in other parts of the world at the same time. But these serve to confirm Soule's objective stance. For example, a direct comparison can be made with the pictures which Alfred H. Burton made of Maoris in New PLATE 79 Zealand during the late seventies. Désiré Charnay's portrait of a Madagascar widow, which dates from 1863, and an anonymous photograph of a Tibetan musician, taken in about 1870, convey an PLATE 77 even greater sense of wildness and alienation.

Photographs of this type were, of course, immensely important to the new science of anthropology. They provided the anthropologists with a major part of their source material. But one can also,

I believe, argue that these images are important in a more general sense. When European artists had attempted to paint the representatives of primitive races, they unconsciously changed and remolded them, just as they changed the landscape when they recorded the scenery of the South Seas. The romantic concept of the "noble savage" gave a distinctive flavour to whatever they produced; and this flavor had nothing to do with the subjects themselves. The camera was less responsive to the preconceptions of those who used it. For the first time the European public was faced with the total otherness of primitive man, and the seeds of doubt about the civilizing mission of Europe began to be sown, though many years were to pass before they germinated.

The third type of photography produced in the West was the frontier's record of itself—its own ways, its own customs, its own people. Most of this type was the work of journeymen professionals who settled down to become part of the local community, and who shared its struggles and its aspirations. The high quality of many of these pictures, and the poetry of the best of them, are at first sight a matter for astonishment. What better expression of the tragic sense than J. J. Pennell's "A Grave in Kansas," for instance?

PLATE 96

It adds much to the impact of these photographs to realize that, with rare exceptions, the photograph was the only indigenous visual art the frontier possessed. This observation is as true of the gold rush towns of Australia as it is of the farming and mining communities of the American west. If painting and drawing existed, they were the work of "primitive" artists, or else they were exotic—made, that is, by imported artists who had no knowledge of frontier conditions. Cheap prints and department store calendars are the best examples of this kind of work. The photographer, on the other hand, was an accepted figure and his professional status was fully recognized by those whom he served.

From the dawn of photography, men had been prepared to struggle with equipment which was both fragile and bulky, and with processes which made great demands both upon manipulative skill and upon physical stamina, in order to capture the images

they wanted. When we think of the immensely strenuous efforts
required to take them, the early photographs of the high Alps PLATE 41
made by the brothers Bisson acquire what is, perhaps, an adven-
titious fascination. Throughout the world, his willingness to
take risks and endure hardships established the photographer in
places where few professional artists were prepared to venture.

To take a case in point: Beaufoy Merlin's detailed record of the
Australian gold-mining towns of Hill End and Gulong is moving,
not only as a sociological document of two communities which
might otherwise have remained unrecorded, but for the beauty of
the images themselves. Merlin uses, with very little variation, the
simplest possible pictorial formulae. Yet his pictures have a
discipline and a refinement which make them works of art. Their
simplicity is the product of thought and of a selective vision. It
does not seem perverse to prefer them to nearly all of the land-
scape painting produced in Australia during the 19th century.

Had photography not been invented, our knowledge of the
expanding universe of the 19th century would be extremely in-
complete. Just as photography was a new art, so, too, it tended to
find one of its most fruitful fields of operation in new lands.

III
In discussing the photographs of Will Soule and Beaufoy Merlin,
I have touched upon one of the principal roles assigned to the
photographer, which was not that of the artist, but that of the
recording angel. Photography's artistic aspirations soon became
controversial, and the controversy has continued to rage until
our own day. Its usefulness as a method of making records has
never, from the moment of its invention, been in doubt. In this
respect its copiousness, instead of being a vice, became a positive
virtue. The photographic image was, in almost all cases, a far
more compact and more reliable way of storing information than
a written description could be—and taking a photograph re-
quired less specialized skill and was, in addition, more rapid, than
making a drawing.

Quite soon, for example, photography began to interest the medical profession; and we find Dr. Hugh Diamond, the alienist who was also, from 1853 onwards, Secretary of the British Photographic Society, using the camera to make striking portraits of the mental patients in his charge. In these, for once, we find the perceptions of the artist confirmed rather than contradicted: Dr. Diamond's photographs often have a striking resemblance to the paintings of madmen by Géricault.

PLATE 113

Photographic records on a large scale were undertaken for a variety of motives, some purely practical, some out of a perceptive concern for the needs of posterity. Among the best-known examples of the latter variety of project are those which were either personally undertaken, or else inspired, by the British Member of Parliament, Sir Benjamin Stone. Stone was a wealthy Birmingham businessman whose interest in photography arose from his passion for travel. Describing the beginnings of his involvement, he wrote:

> One of my early journeys was to Norway and Lapland. There I saw costumes which had not then disappeared from general use and of which I desired to get photographs . . . I had no knowledge of photography at the time, and I remember following a group of people and going with them to a photographer to get him to take a picture of them for me. It is the first photograph in my collection.

By 1868 Stone had started to collect photographs of whatever interested him. For twenty years or so he stocked his collection with the work of professional photographers. The unsatisfactoriness of these photographers drove him, eventually, to learn to use a camera himself; and by 1889 or slightly earlier he began to accumulate his own pictures. During the time that was left to him (he continued until around 1911) he exposed some 15,000 negatives. Birmingham Public Library has an archive of 22,000 photographs either taken or collected by him, and there are substantial collections elsewhere.

Stone is now best-known by the two volumes entitled *Sir Benjamin Stone's Photographs*, published in 1905. These give a good idea of some of his major interests. One volume is entitled *Festivals, Customs, and Ceremonies,* and the other is called *Parliamentary Scenes and Portraits. Festival, Customs, and Cere-* PLATE 64 *monies* is a careful record of the fast-vanishing rural customs of Britain. The pictures are sometimes moving, and often extremely comic. What could be more thoroughly comic than Stone's dead-pan picture of a bard, clad in white robes and a bowler-hat, and playing, with tremendous concentration, a triple-stringed Welsh harp? The impressive thing about these pictures is the way in which they allow the event to speak for itself. Where Stone is consciously humorous, the humor is of the most rudimentary kind, as with the picture which shows the photographer himself in the stocks at Corby Pole fair, Northamptonshire, in the year 1902.

Parliamentary Scenes and Portraits was a project made possible by Stone's membership in the House of Commons. In 1895, he was returned unopposed for the East Birmingham constituency. He determined to photograph not only all his fellow MPs, but the staff of the Palace of Westminster and as many important visitors PLATE 63 as he could catch. There are more than 2,000 of these pictures in the House of Commons Library.

For most of these parliament portraits he used a standard format. Stone describes his method thus:

> I usually manage to secure not a sitting but a standing from them just prior to the meeting of the House in the afternoon. I would place my camera on the terrace, opposite a certain archway, which you will notice recurs again and again in the photographs, and then persuade my friends to allow me to photograph them . . . Of course, some men are better subjects than others, and there was a lack of formality about our proceedings which has given in some cases almost a humourous touch to the portrait.

His method as a portraitist was, in fact, almost the opposite of

that employed by Julia Margaret Cameron. He took most of his subjects at full length, and he worked quickly:

> I have been very successful, I fancy, with the majority of my portraits, partly for the reason that I have only detained the subject for a moment or two. Your ordinary photographer, with his arranging the sitter, clamping the head, suggesting a pose, and in other ways exhausting the patience and time, does not succeed so well in getting a portrait.

The pictures which Sir Benjamin Stone either took on his own account or collected do not, however, exhaust the scope of his activity. He was also the founder of the National Photographic Record Association, which attempted to bring together photographers from all over the country, with the aim of making a record of history as it took place. The declared aim of the Association was "to obtain photographic records of all objects and scenes of interest in the British Isles, and to deposit them, with explanatory notes, in the British Museum, where they may be safely stored, and be accessible to the public under proper regulations." The scheme, however, failed to take off, and lasted for only thirteen years.

If, as we have seen, there was an element of conscious art in the record photography made by Sir Benjamin Stone, this is far from being the case with some of the more immediately practical record projects which were undertaken in the 19th century. A well-known instance of such a record is the vast collection of photographs made for Dr. Barnardo.

Thomas John Barnardo was an Irishman, born in Dublin in 1845, the youngest of eleven children. In 1866, he arrived in London to study at the London Hospital and prepare himself to be a medical missionary in China. Even in London he found missionary work to be done. He began preaching in the streets, and started his own Ragged School at Hope Place in Stepney. He soon gained an intimate knowledge of the plight of the city's thousands of destitute children. In 1871, with the help of the philanthropic

Lord Shaftesbury, he opened his first home for homeless lads. After this, his work for children expanded very rapidly. In May 1874, Dr. Barnardo found it necessary to open a Photographic Department. Already, from about 1870 onwards, he had been commissioning a photographer to take "before" and "after" pictures of the waifs he found.

The photographs were used in two different ways. First, for propaganda purposes. This led to the accusation that:

> The system of taking, and making capital of, the children's photographs is not only dishonest, but has a tendency to destroy the better feelings of the children. Barnardo's method is to take the children as they are supposed to enter the Home, and then after they have been in the Home some time. He is not satisfied with taking them as they really are, but he tears their clothes, so as to make them appear worse than they really are. They are also taken in purely fictitious positions.

The accuser was a local Baptist Minister, perhaps jealous of Dr. Barnardo's success in attracting publicity and funds.

The prime purpose of Dr. Barnardo's venture was not propaganda, but a desire to make and keep a record of the children themselves. The reasons for this desire were twofold. First, "to obtain and retain an exact likeness of each child and enable them [the organization], when it is attached to his history to trace the child's future career." Secondly, "to make the recognition easy of boys and girls guilty of criminal acts, such as theft, burglary or arson, and who may, under false pretences, gain admission to our Homes."

The thousands of photographs in Dr. Barnardo's archives can hardly be classified as examples of conscious art. The photographer is not interested in the impression the picture conveys. The children themselves clearly attach little importance to the business of having their portraits taken. Yet out of this great mass of material, certain images arise with unforgettable force; certain faces imprint themselves, not only on the photographic negative, but

PLATE 112

43

upon the memory of the spectator. In artistic terms, these portraits have much the same status as the "found objects" of modern art. Yet, because they are human and have to do with human emotions, human necessities, they have none of the aesthetic inertia which seems to mark most "found object" works, however distinguished and interesting the finder. To deal with events of this kind, which seem to be typical of photography, we have to invent a wholly new category, that of the "accidental masterpiece" which is a masterpiece nonetheless.

IV

Documentary projects of the kind undertaken in Dr. Barnardo's studio also bring us close to another characteristic of photography, which is the direct impact it had, not only on general knowledge—of new landscapes and new societies, for instance—but also on people's knowledge of the society they lived in.

When we consider the painting and sculpture of the 19th century, and relate it to what we happen to know about the society which produced it, we become aware that whole areas of human experience are omitted or at least censored. These areas appear in some of the literature of the time—in Dickens's novels, for example—but even here they tend to occupy a disproportionately small area. In the latter part of the 19th century, and at the beginning of the 20th, photography became a powerful instrument for social reform. The reason was, once again, its power of authentication. A writer might describe appalling social conditions, but these descriptions could be dismissed by the obstinately complacent as the product of hysteria or prejudice. The photographic image presented evidence that could not be brushed aside in the same fashion. Through the power of the camera, the more prosperous section of the community was confronted with truths that it could no longer refuse to acknowledge.

Yet the camera was not the prime mover in this confrontation. First, there had to be the will to record the terrible conditions which then prevailed. Today the view is sometimes put forward

photography. Marey conducted investigations of animal move-
ment using a somewhat different technique from that employed
by Muybridge, with a single camera and a revolving disc shutter.
This meant that all phases of movement were recorded on the
same negative. His assistant from 1882 to 1894 was George Demeny
(1850–1917).

PAUL MARTIN (1864–1944)

Martin was born in Alsace-Lorraine, and his family moved to
London in 1872. At the age of sixteen he was apprenticed to a
wood-engraver. His enthusiasm for photography dated from 1884,
when he purchased his first camera, but it was not until 1892 that
he found his true vocation in the making of "candid," unposed
pictures. He turned professional in 1899, in partnership with H. G.
Dorrett, a fellow-member of the West Sussex Photographic
Society. His professional work, however, never had the quality of
the spontaneous street scenes and snapshot-like pictures of life
at the seaside that he took for his own pleasure.

ALPHONSE MUCHA (1860–1939)

This Czech painter established himself in Paris as one of the most
celebrated of all Art Nouveau poster designers. He used photo-
graphs in the preparation of his work, and was also an accom-
plished snapshot photographer.

EADWEARD JAMES MUYBRIDGE (1830–1904)

Muybridge, who was born in England, had a successful career as a
bookseller in San Francisco before turning photographer. He
specialized, like many other photographers of the period, in
stereo views. In May 1872, the railroad magnate Leland Stanford
engaged him to take pictures to try and settle a controversy with
a friend. The question was: did a fast trotting horse ever have all
its feet off the ground at the same moment? The photographs
taken by Muybridge in 1872 at Sacramento race course were in-
conclusive. The photographer then, after shooting his wife's lover
and successfully pleading "justifiable homicide," left America to

make a series of publicity photographs for the Pacific Mail Steamship Co, and the Central Pacific Railway Co. (both Stanford-controlled). His travels took him to Panama, Mexico and Guatemala, and the study of animal locomotion was not resumed until 1877. A battery of cameras was used to record the successive phases of movement. These pictures effectively destroyed earlier theories held by artists and scientists on the subject and revealed that long-established conventions, such as the "flying gallop," had nothing to do with reality. In 1879, still with Stanford's backing, an equally revolutionary study of human locomotion was begun. Muybridge rapidly became celebrated, and traveled and lectured widely. This celebrity led to a falling out with Stanford, and a complicated law suit. Later, Muybridge carried out a further programme of research with the backing of the University of Pennsylvania. In around 1894 he returned to England, and arranged for the publication of his two great collected volumes—*Animals in Motion* (1899) and *The Human Figure in Motion* (1901).

NADAR (pseudonym of Gaspard Félix Tournachon, 1820–1910)
Nadar was originally a journalist and caricaturist who took up photography for financial reasons and discovered that he had a gift for it. He never abandoned his first two professions, and through the training they had given him he developed a keen eye for human idiosyncrasy. His portraits are notable for their forcefulness and directness. A colorful personality, six-foot high and with flaming red hair, Nadar was a friend of most of the leading artists, writers and musicians of his time. Many of them used his studio in the Boulevard des Capucines in Paris as a kind of club. It was in this studio, in 1874, that the first Impressionist Exhibition was held. A keen balloonist, Nadar made the first aerial photographs in 1858. In 1860 he used electric light to photograph the catacombs and sewers of Paris. He retired from photography in 1886, returning for one last foray with the invention of the photo-interview. In 1899 he published a book of memoirs, *Quand j'étais Photographe*.

CHARLES NÈGRE (1820–c.1880)

Nègre was a well-known academic painter, not quite of the first rank, who may have been attracted to photography because he hoped to use it as an aid to his painting. He worked in the medium from 1851 onwards, and produced some of the most beautiful of all 19th century genre scenes. The series of pictures of the Imperial Asylum at Vincennes, some of which rival Vermeer, were commissioned by Napoleon III. Nègre also had a portrait studio in Paris.

WILLIAM NOTMAN (1826–1891)

Notman was born in England, but was active in Canada from the mid-1850's onwards. He built up a large and successful business enterprise, with studios in Toronto, Montreal, Ottawa and Halifax, Nova Scotia. Later still, his activities spread to New York and Boston. The Notman output is predictably vast and variable in quality. It can seldom be attributed with certainty to any one photographer, but is nevertheless extremely rich in fascinating images.

TIMOTHY H. O'SULLIVAN (c.1840–1882)

O'Sullivan was born in New York and trained by Brady. He later worked in the Brady studio in Washington, and with Alexander Gardner in making a photographic record of the Civil War, 1861–5. After the war he was, from 1867 to 1869, photographer on the United States Geological Exploration of the Fortieth Parallel. In 1870 he went to Panama on the Darien Expedition, and in 1871 accompanied Lt. Wheeler's survey west of the 100th meridian. In 1880, on the joint recommendation of Brady and Gardner, O'Sullivan was appointed chief photographer of the United States Treasury Department.

JOSEPH J. PENNELL

Pennell was active in Kansas, 1895–1909. The University of Kansas has a notable collection of his glass negatives.

HENRY POLLOCK (1826–1889)

Pollock, later Master of the Supreme Court of Justice, was very probably the author of a group of very accomplished photographs which recently appeared in a London saleroom. These photographs are signed 'H.P.', and must have been taken when Pollock was a very young man. Other photographs in the group are signed in full by his brother Frederick Pollock.

OSCAR GUSTAVE REJLANDER (1813–1875)

Rejlander is said to have been born in Sweden, and to have visited Italy and Spain before settling in England. He was established in Lincoln in 1841, and by 1846 had moved to Wolverhampton, where he is listed as an "artist" in local directories. Photography claimed him in the early 1850's, and he soon progressed from making "artistic" genre scenes to work that entailed the combination of several different negatives. His *Two Ways of Life* of 1857, which was made up from over thirty different negatives, attracted the attention of Prince Albert and made Rejlander famous. Later, however, he was to react against this type of work. In 1860 Rejlander moved to London, where he concentrated on making studies for artists to work from, and subtle genre studies, often of children. He contributed to Charles Darwin's *The Expression of the Emotions in Man and Animals*, 1872.

JACOB A. RIIS (1849–1914)

The Danish-born Riis was police court reporter on the *New York Tribune* from 1877. Since police headquarters were then at Mulberry Street, he became intimately acquainted with New York's East Side slum district. Determined to try and improve conditions there, he learned to make photographs as a means of documenting what he saw. Many of his pictures were taken by the primitive and dangerous magnesium-flash method. His book, *How the Other Half Lives*, caused a sensation when it was published in 1890; and he produced a number of follow-up volumes, such as *The Children of the Poor* (1892), and *Out of Mulberry Street* (1898).

JAMES ROBERTSON (active 1852–1865)

Robertson was the superintendent and chief engraver of the Imperial Mint at Constantinople. Working with Felice A. Beato, he began a series of views of Mediterranean cities and antiquities in 1853, then went on, still with the same partner, to document the concluding stages of the Crimean War in 1856. Later he and Beato went to India, and recorded scenes connected with the Indian Mutiny. When Beato continued his travels, Robertson remained in India, working in association with Shepherd of Simla.

HENRY PEACH ROBINSON (1830–1901)

A "High Art" photographer who was influenced by Rejlander in his use of combination negatives. Some of his compositions, such as "The Lady of Shalott" (1861) were done under the spell of Pre-Raphaelite painting. Robinson himself later condemned this as "very weird, and very untrue to nature."

DANTE GABRIEL ROSSETTI (1828–1882)

The Victoria & Albert Museum has a series of eighteen photographs of Jane Morris, taken for Rossetti in July 1865. The poses are characteristic of the paintings he was making at the period, and were obviously arranged by Rossetti himself. The photographs were probably intended to serve as studies for paintings, and thus to take the place of preparatory drawings.

JEAN BAPTISTE SABATIER-BLOT (1801–1881)

Nothing much seems to be recorded about this French portrait photographer, except his dates of birth and death.

NAPOLEON SARONY (1821–1896)

This Canadian painter and portrait photographer had a studio in Birmingham in the mid-1860's. In 1866 he set up in business in New York, where he scored a substantial success. His brother, Oliver Sarony (1820–79), remained in England and made his studio in Scarborough the most successful out-of-London establishment of its type.

CAMILLE SILVY

French, a diplomat, an aristocrat and an amateur photographer, Silvy broke with the traditions of his class in 1859 by setting up as a professional. Previously he had produced a series of exceptionally beautiful landscape photographs. Now, in his elegant portrait studio in Porchester Terrace, London, he produced what may well be the finest of all cartes de visite. Gernsheim calls him "the Van Dyck of photography." By 1869 Silvy had made enough money to sell the business and retire.

WILL SOULE (1836–1908)

As a Union soldier, Will Soule was severely wounded at Antietam. Later, after working as a clerk in Washington, D.C., he was employed in a photographic gallery at Chambersburg, Pennsylvania. The gallery burned down, and in 1867 Soule decided to "go west" in the hope of improving his health. He took a photographic outfit with him. By about 1870, he seems to have been employed as an official photographer at Fort Sill. He is known to have run a photographic studio there. The newly-built fort was, from its inception, the Military Control Headquarters for the Comanche, the Kiowa, the Kiowa-Apache, the Wichita, the Caddo, and other tribes, and Soule had many opportunities of seeing and photographing Indians. He returned east in around 1875 and settled in Boston, where he continued to run a photography business.

ALBERT SANDS SOUTHWORTH (1811–94) and JOSIAH JOHN HAWES (d. 1901)

These portrait and landscape photographers ran a studio in Boston from about 1850 onwards.

EDWARD STEICHEN (b.1879)

Steichen is one of the great names in turn-of-the-century photography. He began work as a photographer in 1896 and held a one-man exhibition in Paris in 1902, in which year he was one of the founder-members of the Photo-Secession. In 1905, in partner-

ship with Alfred Stieglitz, he started the Photo-Secession Gallery at 291 Fifth Avenue. Up to the First World War, Steichen made use of controlled print processes; after the war, he was to turn to straight photography. In the 20's and 30's he was a celebrated fashion photographer, working for *Vogue*; from 1947 onwards he was Curator of Photography at the Museum of Modern Art, New York.

CARL FERDINAND STELZNER (c. 1805–1894)

A painter of miniatures who turned photographer in partnership with Hermann Biow (1810–50). Their business was situated in Hamburg, and in the year their partnership began, Stelzner and Biow made what are generally considered to be the first news photographs—daguerreotypes recording the devastation caused by a serious fire in the city.

ALFRED STIEGLITZ (1864–1946)

From the first an advocate of "pure" photography, without manipulation of the print process, Stieglitz made his reputation with a series of photographs of everyday life in New York, taken from 1892 onwards. These were "pictorial" only in the sense that they had a finely-honed pictorial intelligence about them. A man of forceful personality, Stieglitz was responsible for the foundation of the Photo-Secession in 1902, and of the Photo-Secession Gallery (known later as "291") at 291 Fifth Avenue in 1905. From 1903 to 1917 he edited *Camera Work*, the most influential of all photographic magazines.

FRANK MEADOW SUTCLIFFE (1853–1941)

A member of the new school of "naturalistic" photographers founded (or at least publicized) by Emerson, Sutcliffe was associated all his life with the port of Whitby, and with the coast and countryside near it. He worked commercially as a portrait and carte-de-visite photographer, but his best work was done for his own pleasure, though prints appeared later in exhibitions. He

worked from 1875 onwards, retiring in 1922. In 1892 he was a founder-member of the Linked Ring Brotherhood.

HENRY TAUNT (1842–1922)

The son of a plumber and glazier, Taunt was apprenticed in 1856 to Edward Bracher, the pioneer of photography in his native town of Oxford. He set up on his own c. 1868. His book, *A New Map of the River Thames*, published in 1872, brought him at least local celebrity, and he was soon established as an Oxford "character"— an organizer of entertainments, a political controversialist, and a successful publisher of guidebooks and post cards.

JOHN THOMSON (1837–1921)

A Scotsman who began as a student of chemistry at Edinburgh, and whose early career as a photographer was spent in the Far East. In the 1870's he took a series of striking photographs showing street and working class life in London. These were published as *Street Life in London* (1877), with a text by Adolphe Smith. Thomson was a Fellow of the Royal Geographical Society.

DAVID WILKIE WYNFIELD (1837–1887)

This grand-nephew of David Wilkie was himself a painter. His series of photographic portraits of mid-Victorian Royal Academicians in fancy dress influenced Julia Margaret Cameron.

HEINRICH ZILLE (1858–1929)

A German graphic artist whose work appeared in *Simplicissimus*. He exhibited with the Berlin Secession.

The Invented Eye:
A Portfolio of Photography

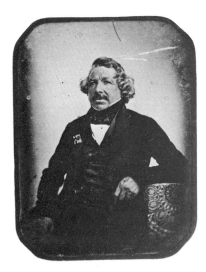

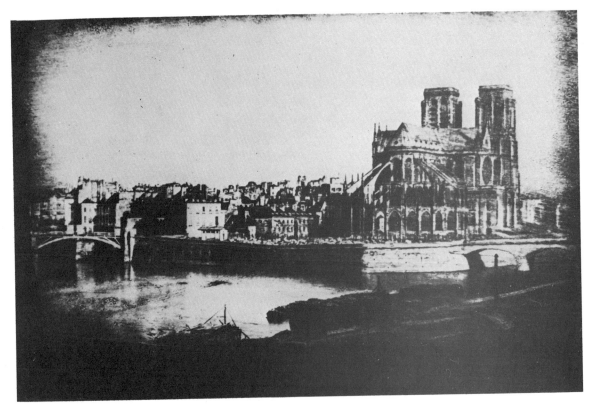

1. J. B. SABATIER BLOT: J. M. Daguerre, 1844 (daguerreotype)

2. J. M. DAGUERRE: Paris. Notre Dame from the Pont des Tournelles. 1838–9 (daguerreotype)

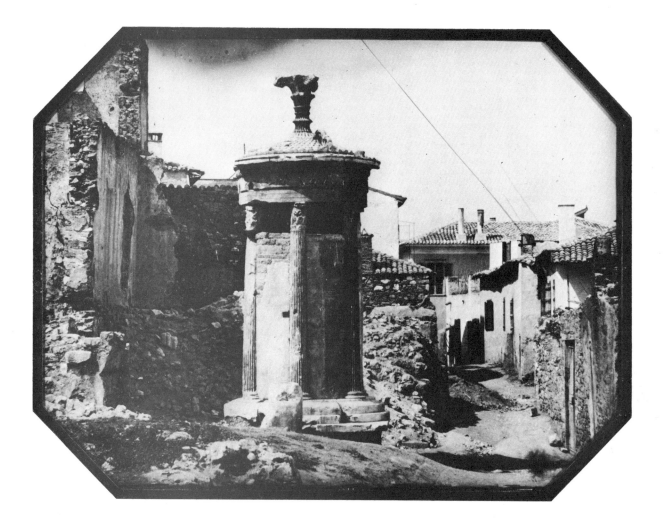

3. BARON GROS: The Monument of Lysicrates, Athens, 1850 (daguerreotype)

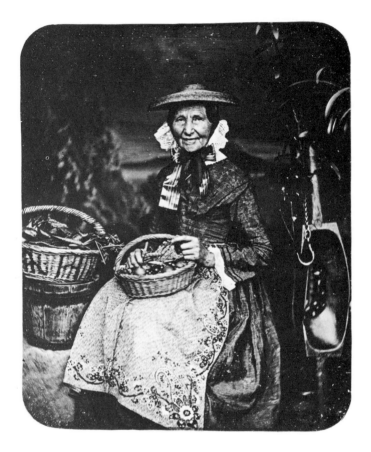

4. C. F. Stelzner: Mother Albers, the family vegetable woman, 1840's (daguerreotype)

5. PLATT D. BABBITT: Man stranded in the Niagara River, 1853 (daguerreotype)

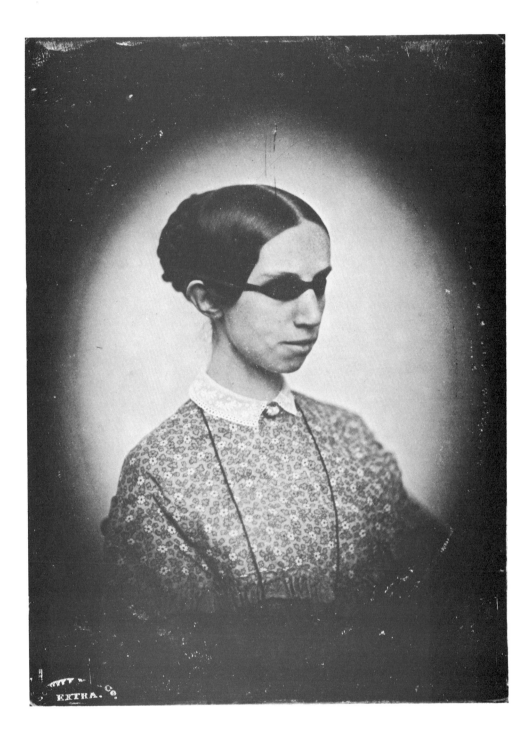

6. SOUTHWORTH AND HAWES: Laura Bridgman, the blind poet (daguerreotype)

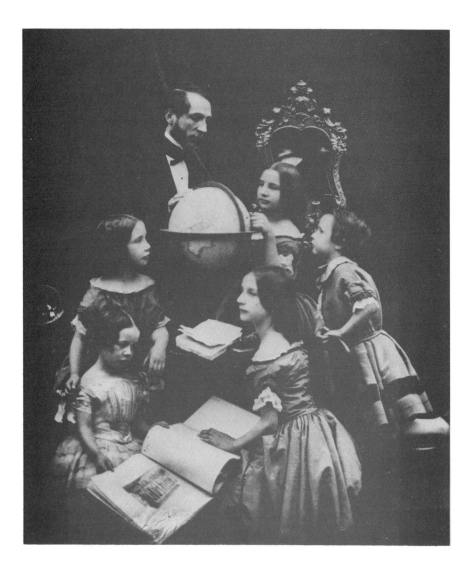

7. Antoine Claudet: The Geography Lesson, c. 1850 (daguerreotype)

8. W. H. Fox Talbot: Study of Trees, c. 1840

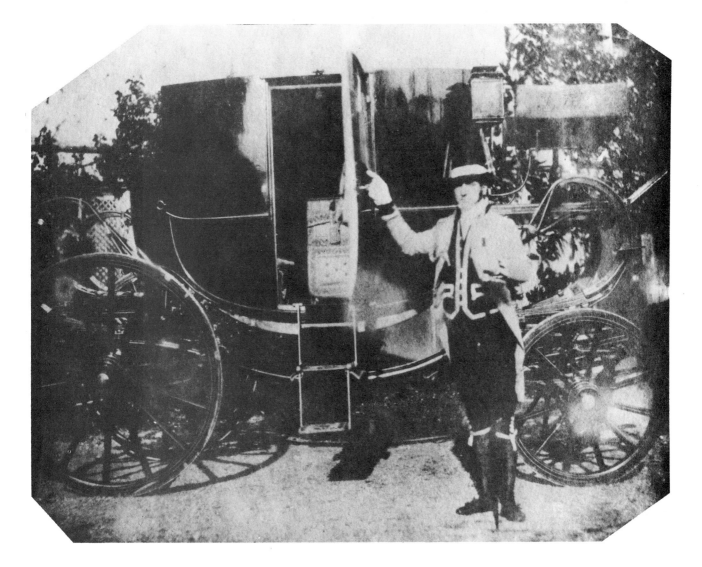

9. W. H. Fox Talbot: A Carriage

10. W. H. Fox Talbot: Flowers in a Vase, 1840's

11. Hɪʟʟ and Aᴅᴀᴍsᴏɴ: Colinton Woods

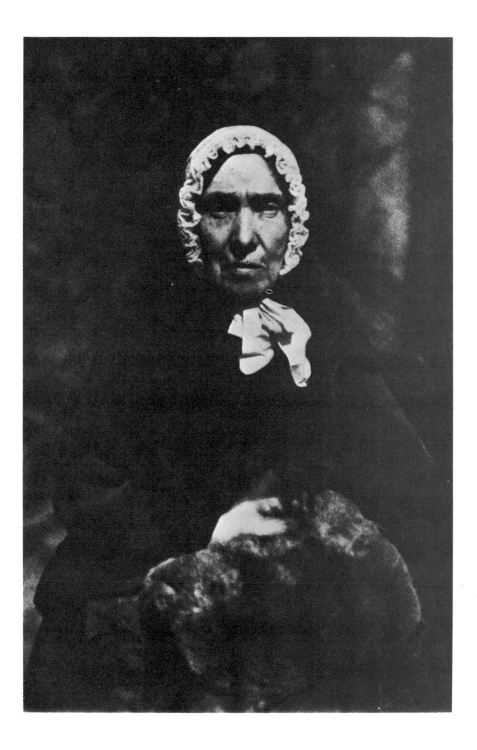

12. HILL AND ADAMSON: Mrs Isabella Burns Begg

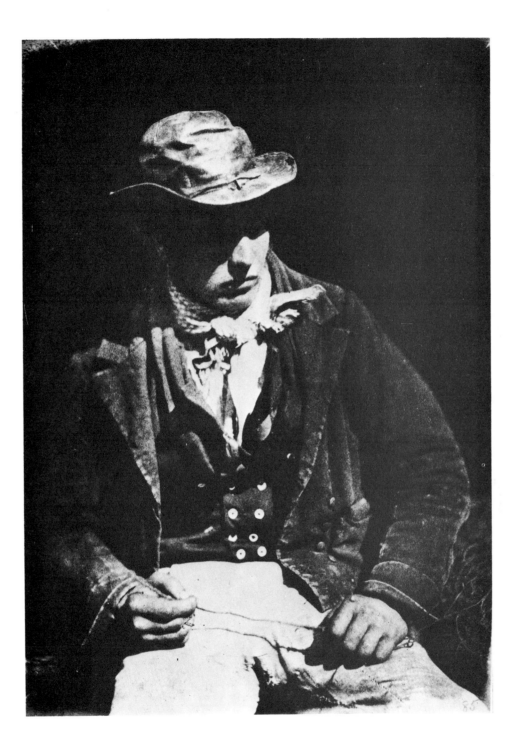

13. HILL and ADAMSON: Redding the line—portrait of James Liston

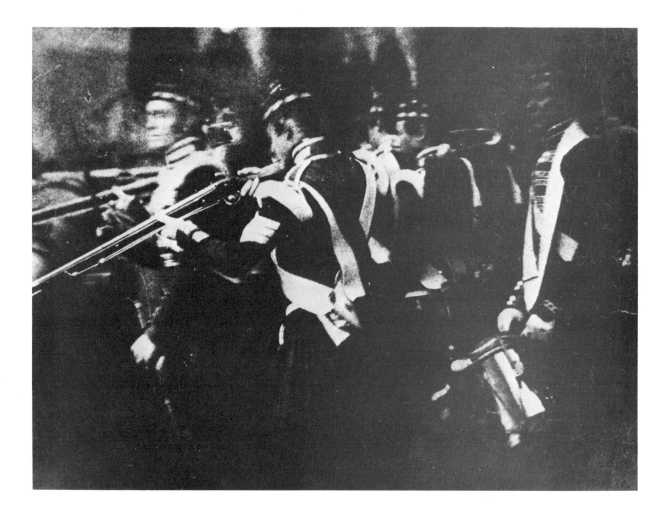

14. HILL and ADAMSON: Highlanders at Edinburgh Castle

15. LEWIS CARROLL: Alice Liddell and Lorna Liddell

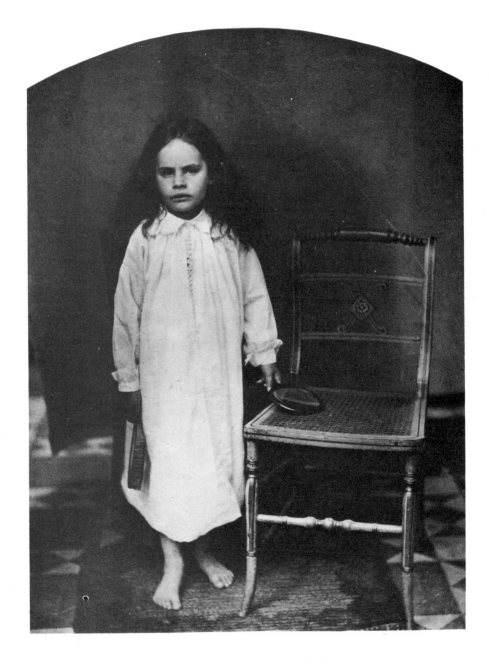

16. LEWIS CARROLL: "It won't come straight"—Irene MacDonald, July 1863

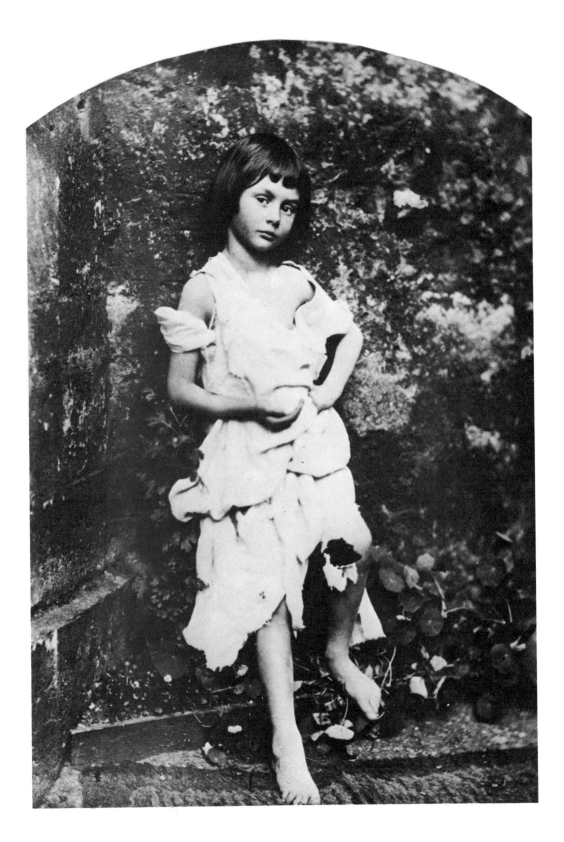

17. Lewis Carroll: Alice Liddell as a beggar-maid

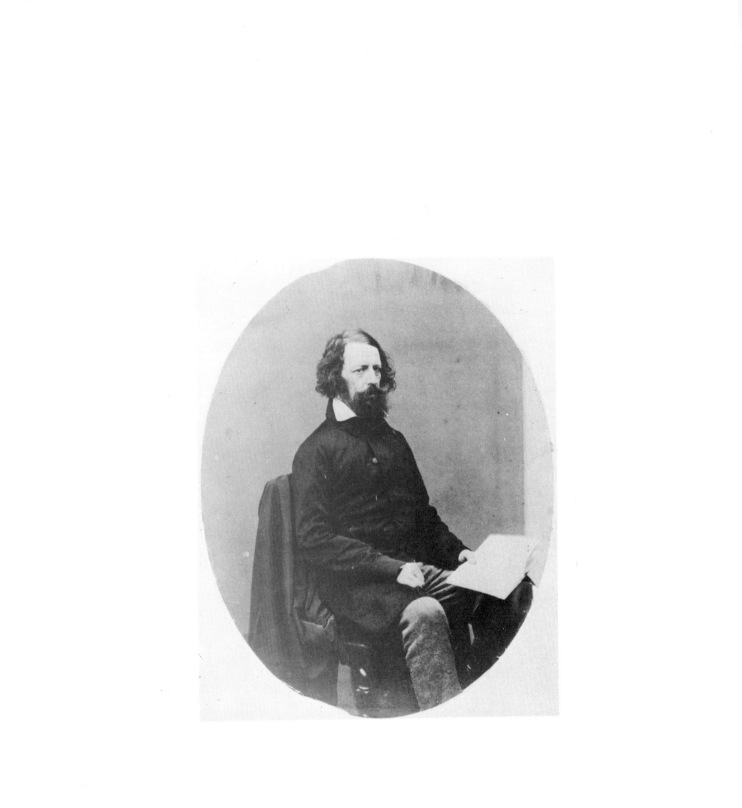

18. LEWIS CARROLL: Tennyson, September 28th, 1857

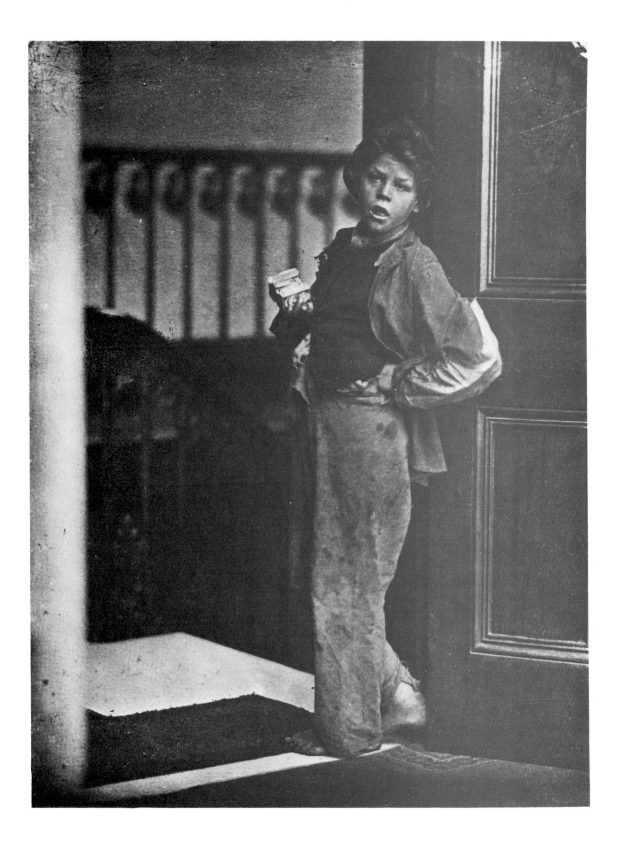

19. O. G. Rejlander: "Lights, sir!" 1872

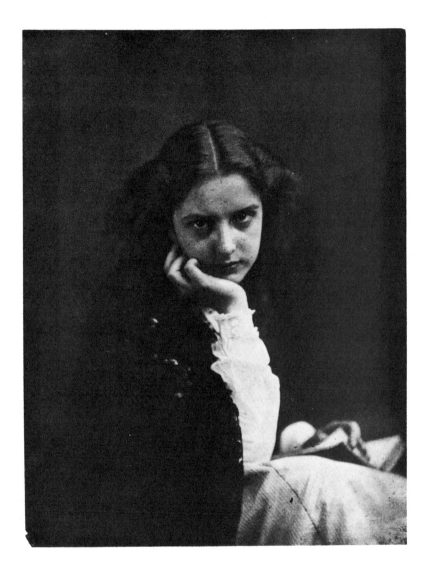

20. O. G. REJLANDER: "Is it true?" c. 1862–8

21. O. G. Rejlander: Girl at a Window, c. 1864

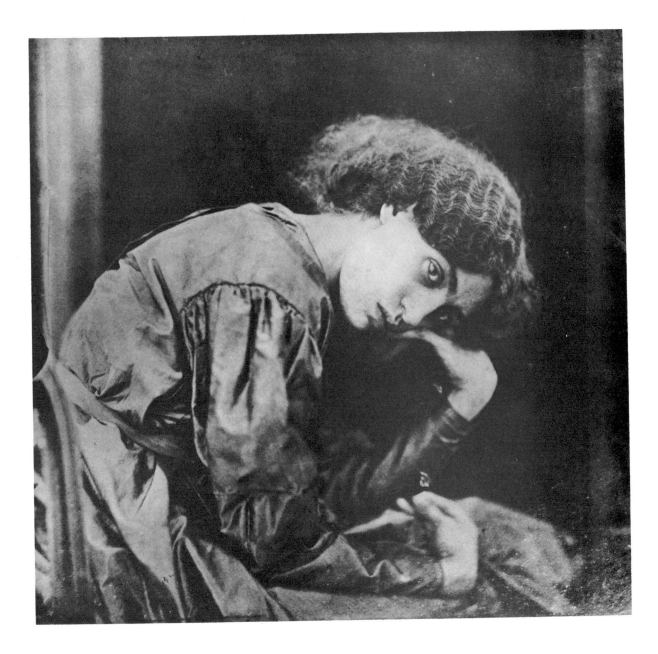

22. Dante Gabriel Rossetti: Jane Morris

23. DAVID WILKIE WYNFIELD: W. Holman Hunt in fancy dress, 1850's

24. JULIA MARGARET CAMERON: "Iago, study from an Italian," c. 1865

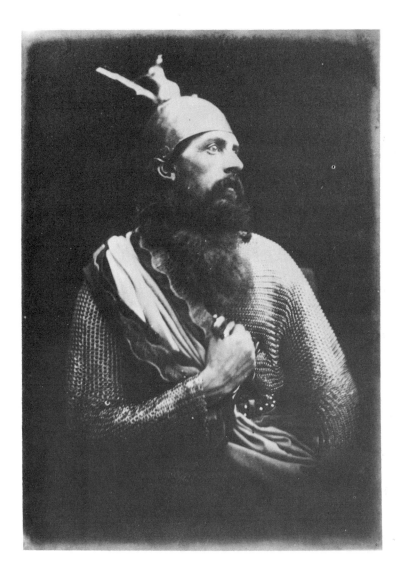

25. JULIA MARGARET CAMERON: King Arthur, illustration to Tennyson's *Idylls of the King*, 1875

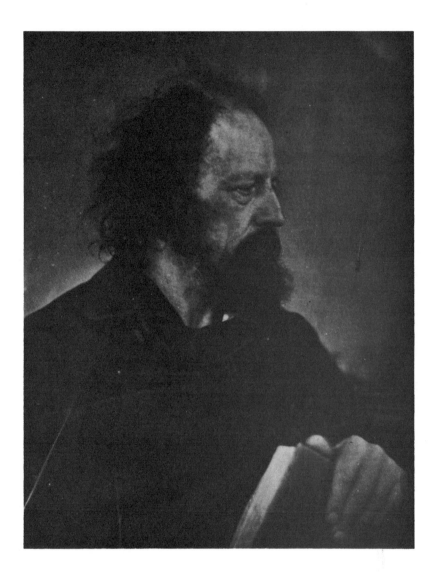

26. JULIA MARGARET CAMERON: "The Dirty Monk"—Tennyson with a book, Freshwater, May 1865

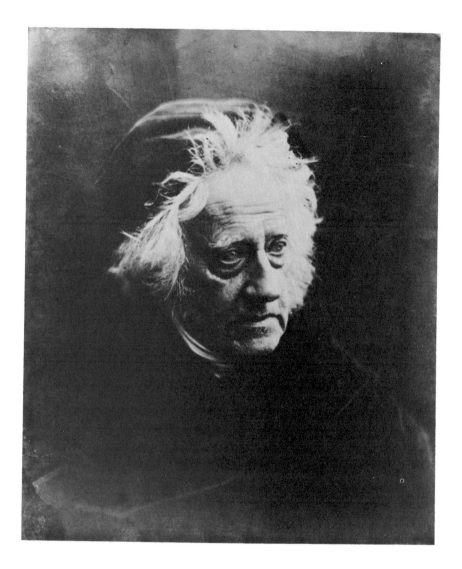

27. Julia Margaret Cameron: Sir John Herschel, April 1867

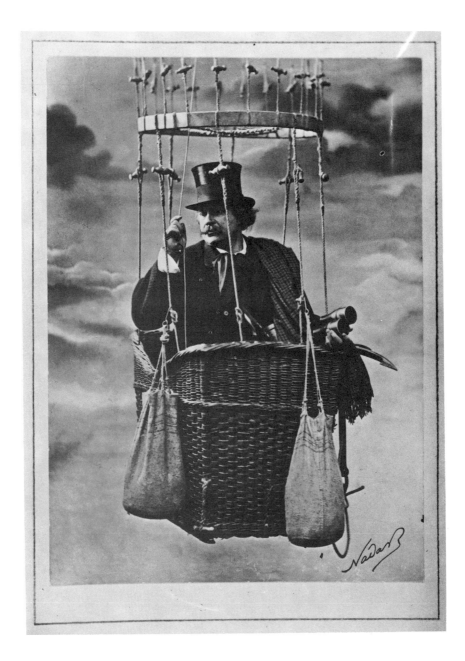

28. NADAR: Self-portrait in a balloon, c. 1863

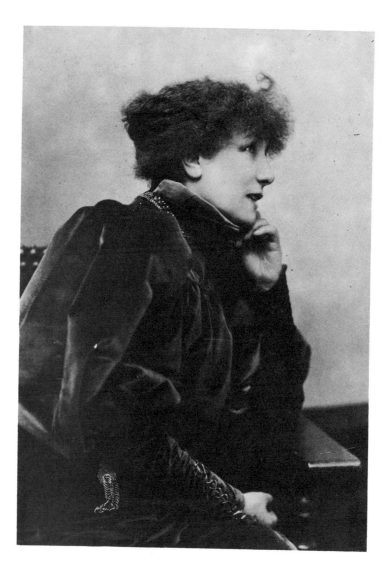

29. NADAR: Sarah Bernhardt, 1859

30. NADAR: Alphonse Daudet

31. Etienne Carjat: Baudelaire, c. 1863

32. ETIENNE CARJAT: Gustave Courbet, c. 1871

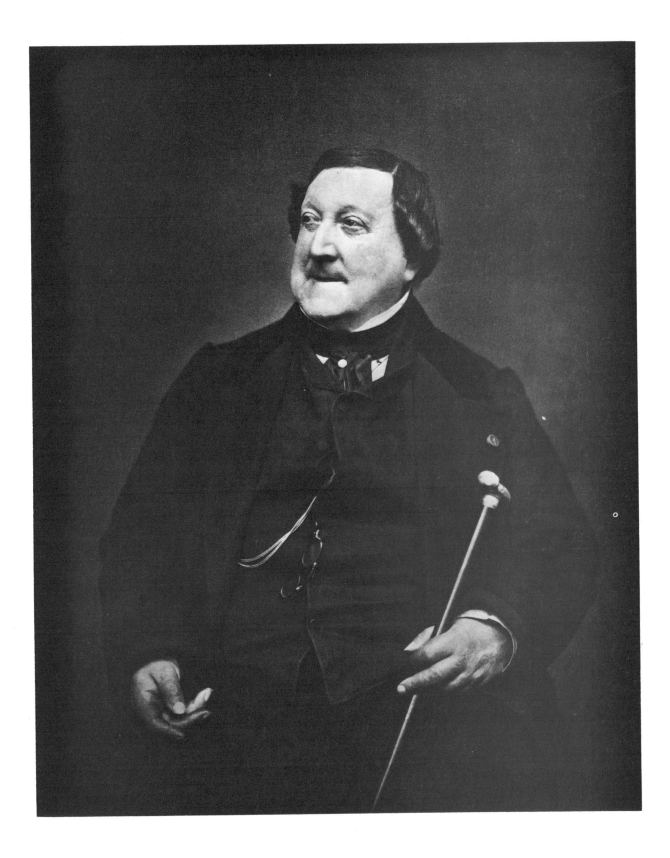

33. Etienne Carjat: Rossini

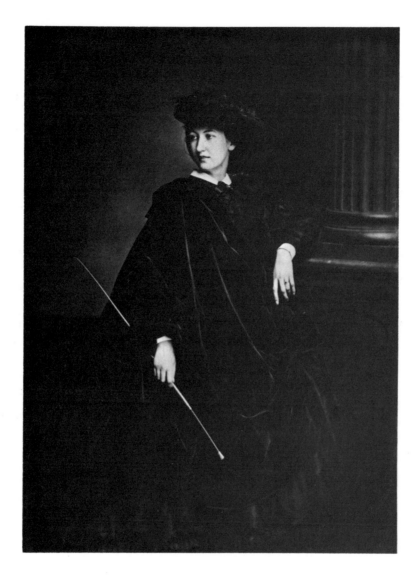

34. Antoine Adam-Salomon: Lola Montez, c. 1860

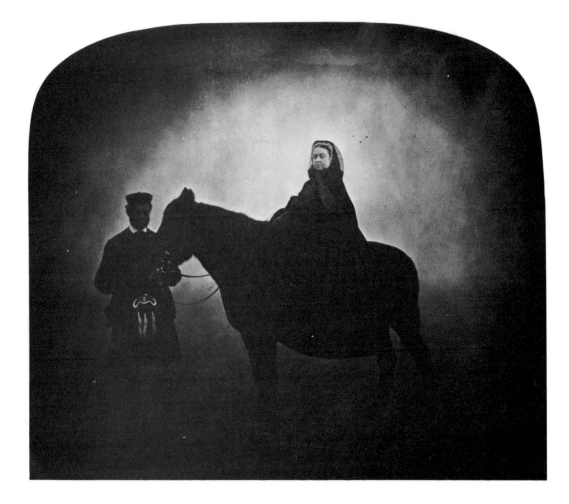

35. ANONYMOUS: Queen Victoria and John Brown

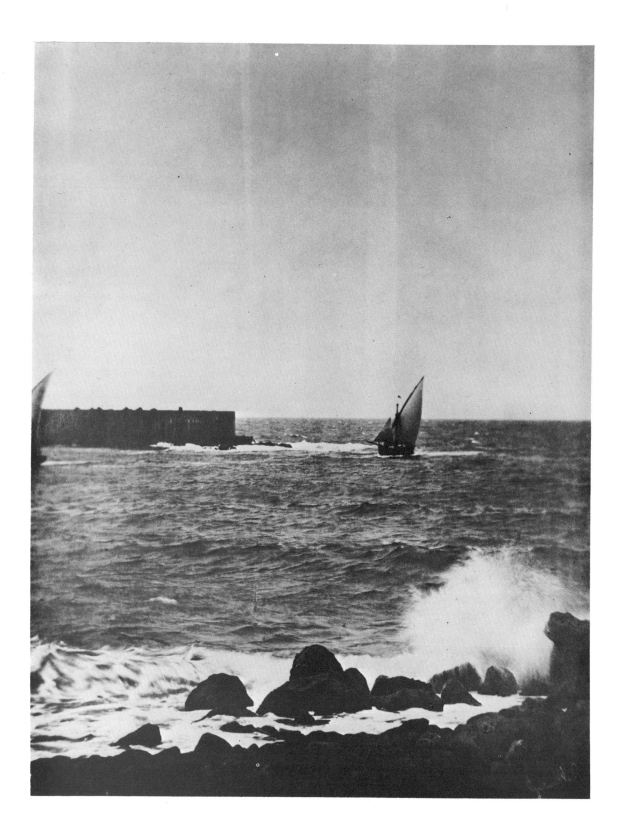

36. GUSTAVE LE GRAY: Broken Wave, Port de Sète, 1856

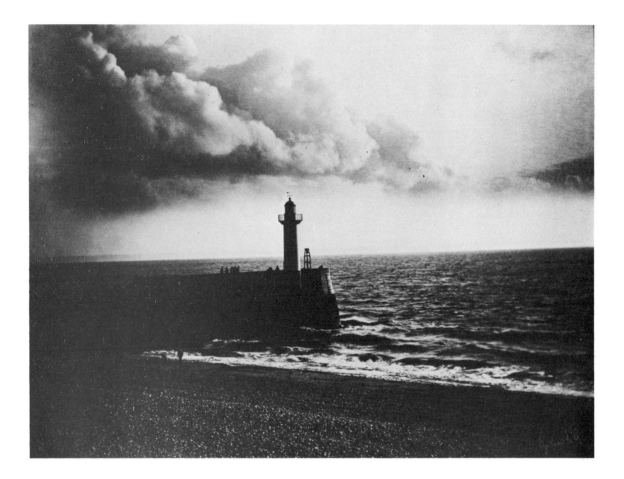

37. GUSTAVE LE GRAY: Seascape with Lighthouse

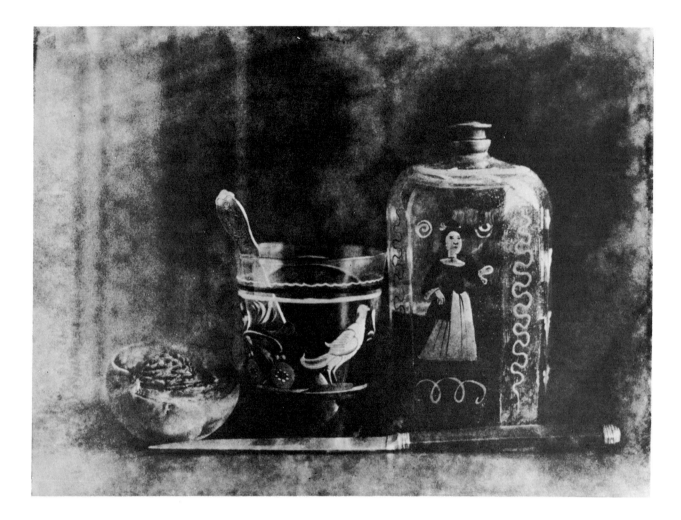

38. HENRI LE SECQ: Still Life, Fantasie Photographique

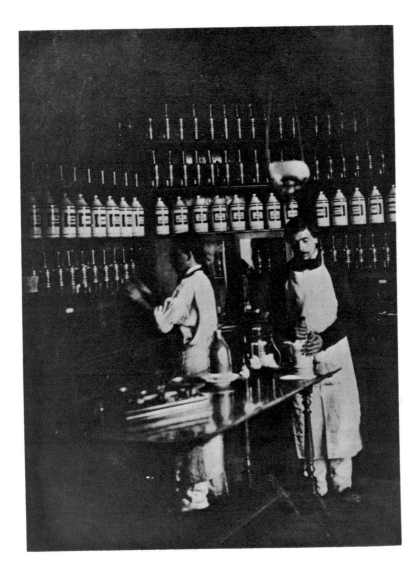

39. CHARLES NÈGRE: The Pharmacy, Asile de Vincennes, 1860

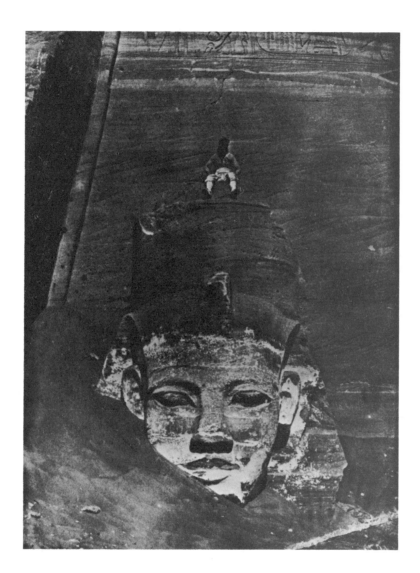

40. MAXIME DU CAMP: Colossus of Rameses II at Abu Simbel, 1852

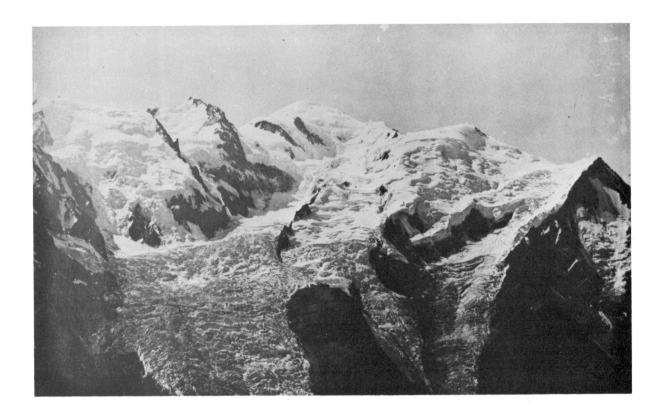

41. BISSON FRÈRES: The Summit of Mont Blanc from Chamonix, c. 1861–3

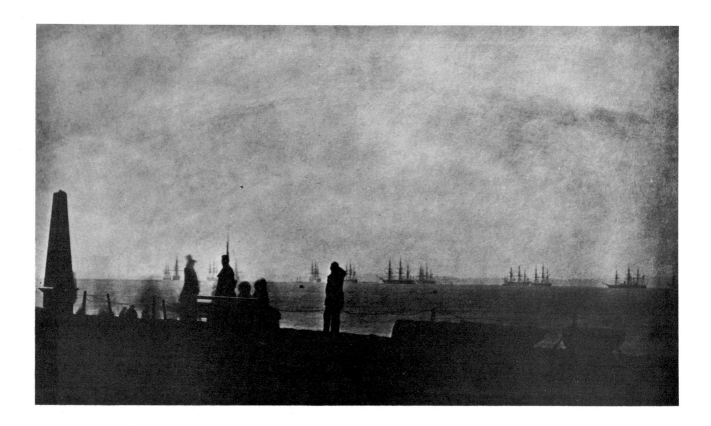

42. ROGER FENTON: The Fleet at Anchor, 11th March, 1854

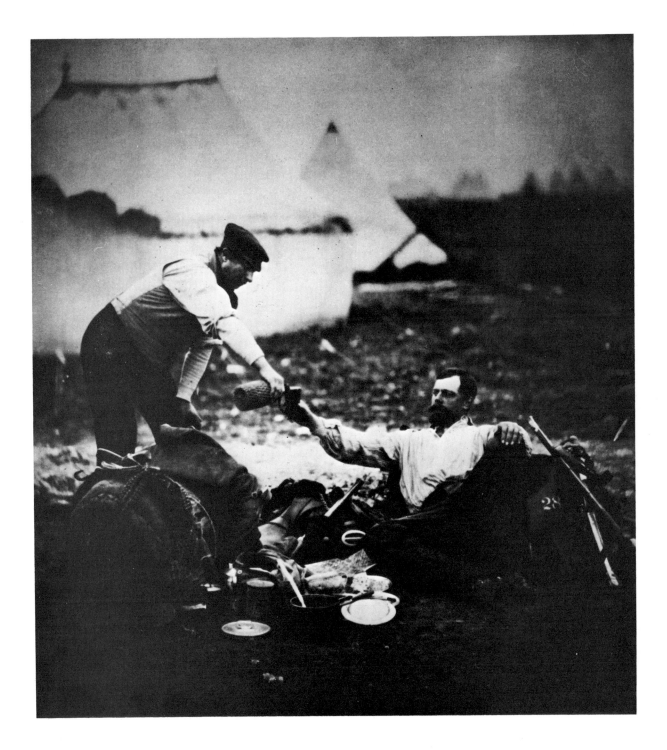

43. ROGER FENTON: "His day's work over"—Lt. Col. Hallowell and his servant, the Crimea, 1855

44. ROGER FENTON: The Cathedral of the Resurrection, the Kremlin

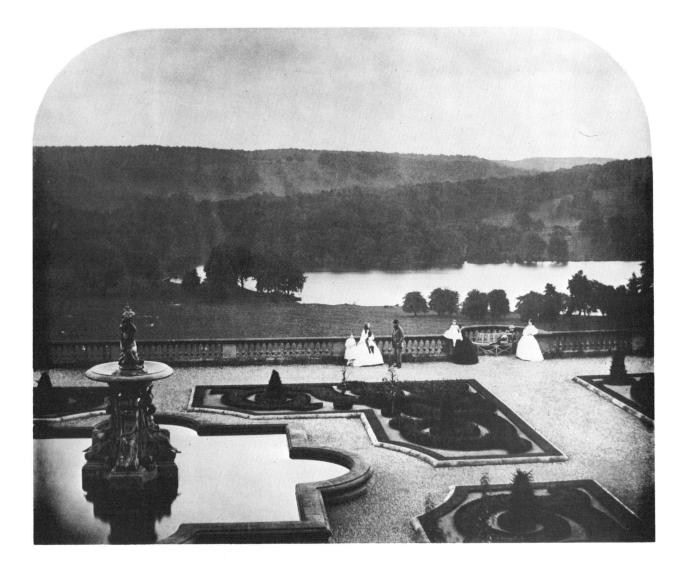

45. ROGER FENTON: The Terrace at Harewood House, 1860

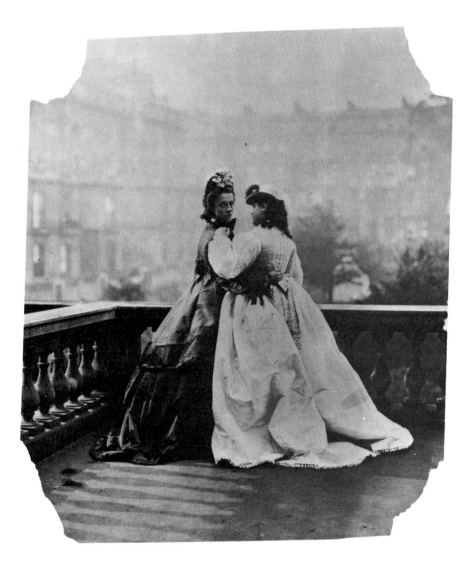

46. LADY HAWARDEN: Girls on a balcony

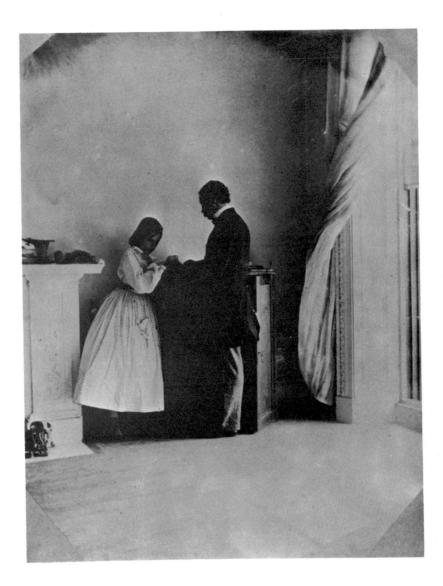

47. LADY HAWARDEN: Man and girl in a room

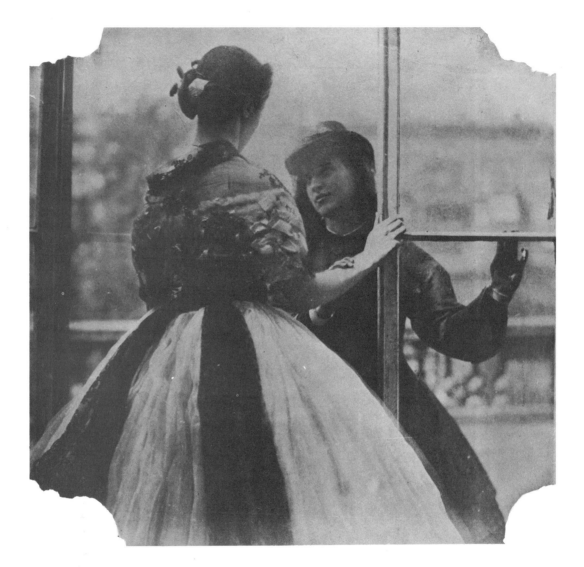

48. LADY HAWARDEN: Girls at a window

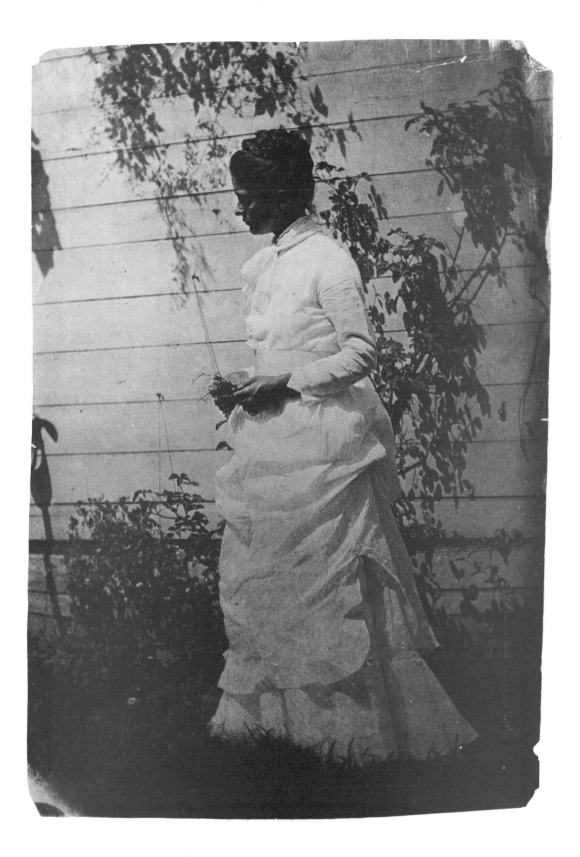

49. THOMAS EAKINS: Mary MacDowell (Mrs. Eakins's sister), c. 1886

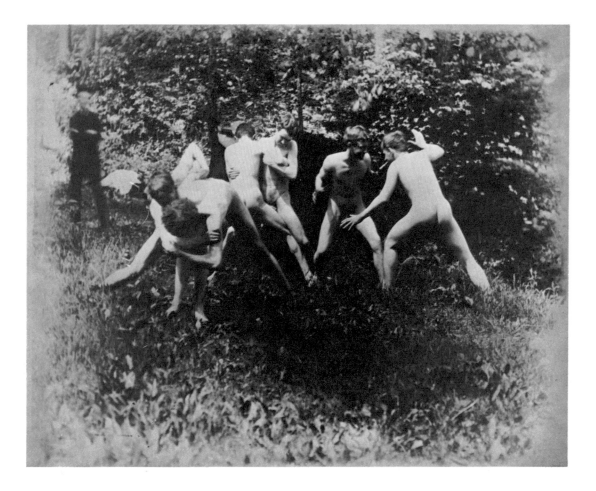

50. Thomas Eakins: Students Wrestling, c. 1883

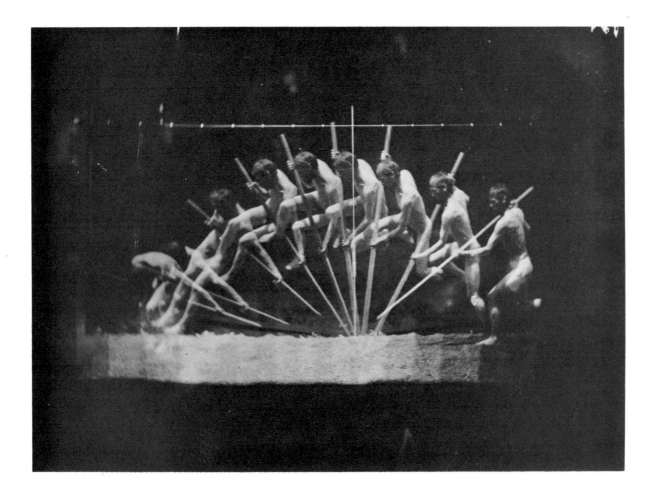

51. THOMAS EAKINS: Multiple exposure photograph of George Reynolds pole-vaulting, 1884

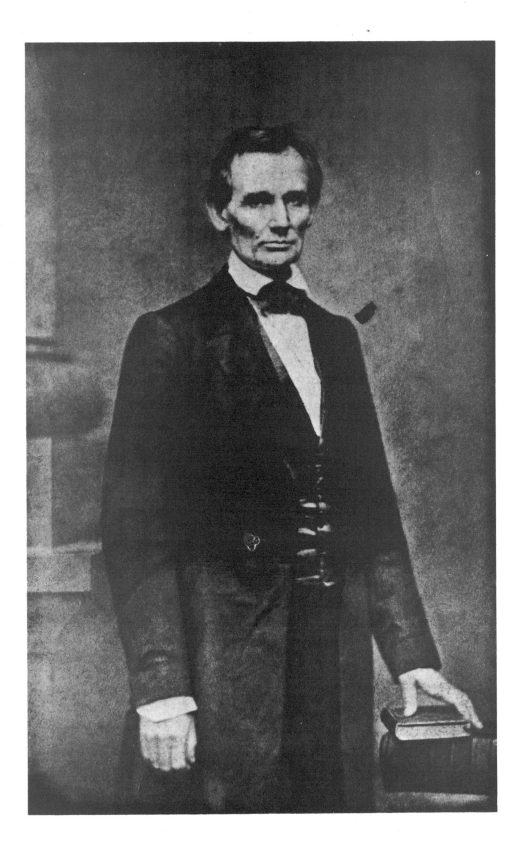

52. MATHEW B. BRADY: Abraham Lincoln, February 27th, 1860

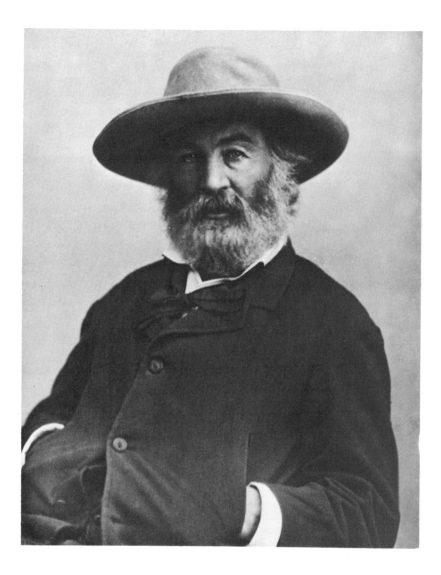

53. Matthew B. Brady: Walt Whitman

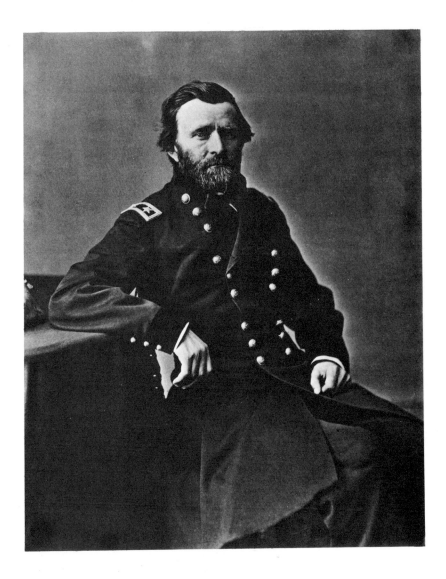

54. MATHEW B. BRADY: General Ulysses S. Grant

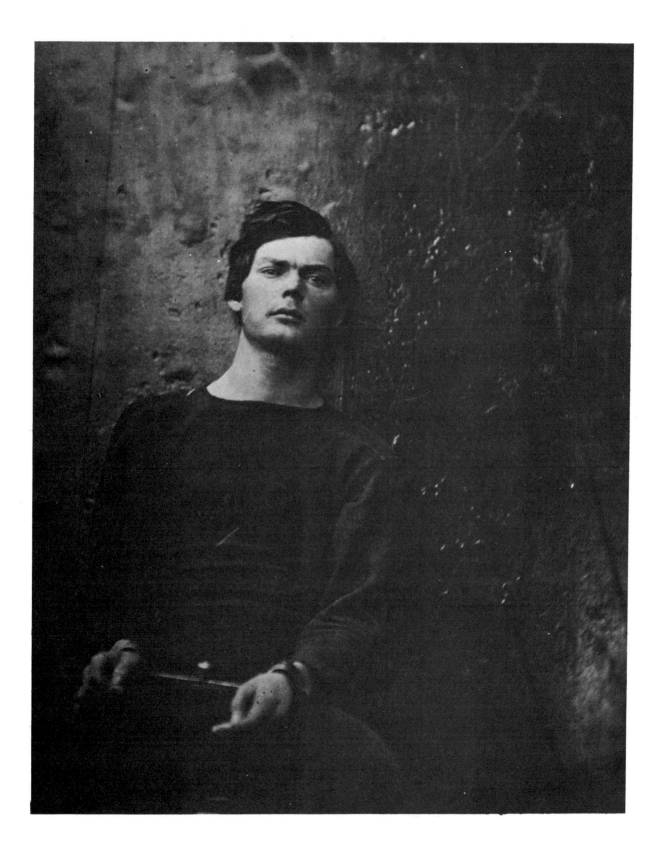

55. MATHEW B. BRADY: Lewis Payne, one of the Lincoln conspirators, 1865

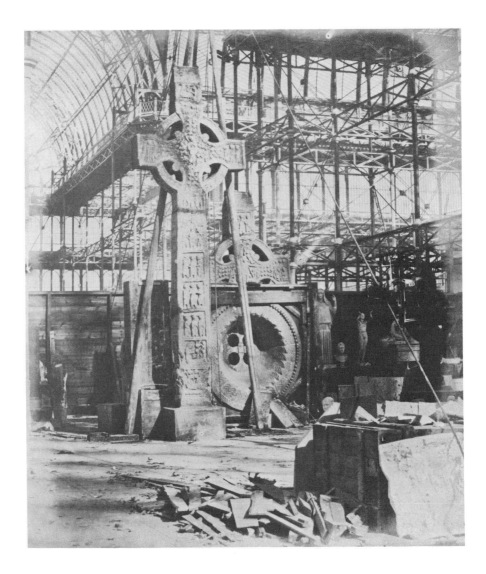

56. P. H. DELAMOTTE: The Irish crosses in the nave of the Crystal Palace, 1854

57. HENRY PEACH ROBINSON: In Wales, 1860's

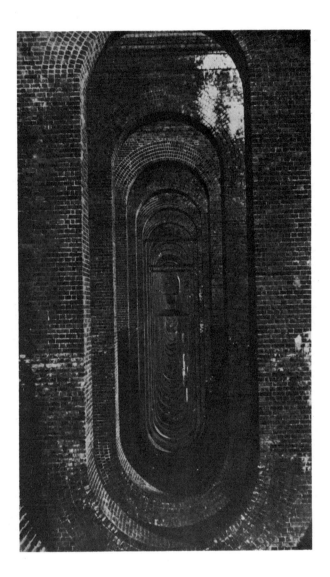

58. "H. P." (perhaps Henry Pollock): A viaduct on the South Eastern Railway, 1850's

59. Lewis Hine: A glimpse of a steel shop, 1900's

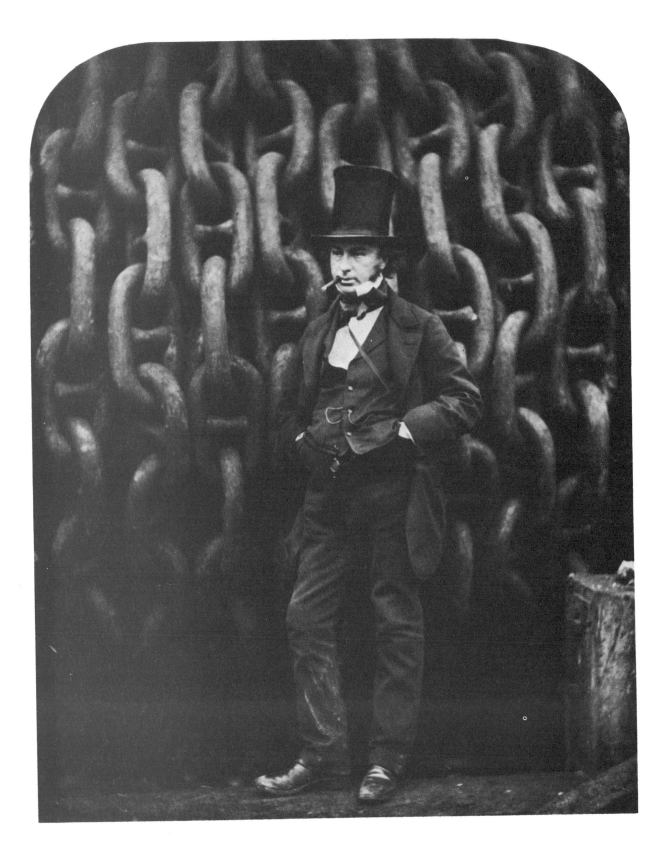

60. ROBERT HOWLETT: Isambard Kingdom Brunel against the anchor chains of the "Great Eastern," 1857

61. NOTMAN STUDIOS: Engine Room of the "Great Eastern," July 1861

62. ADOLPHE BRAUN: Flower Arrangement, c. 1859

63. Hugh W. Diamond: Still Life

64. SIR BENJAMIN STONE: The Kern Baby, Whalton, Northumberland, 1901

65. SIR BENJAMIN STONE: Inside Big Ben

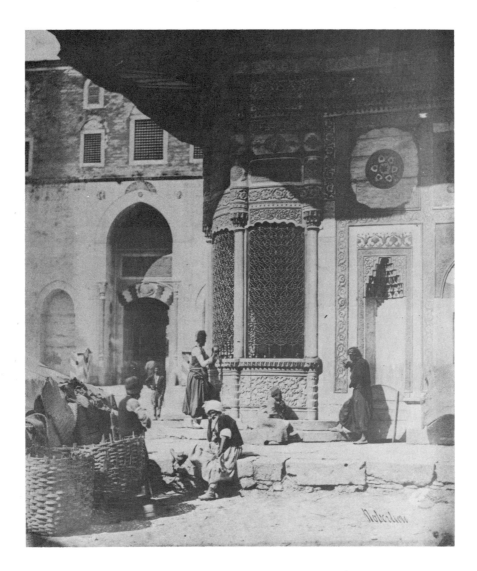

66. JAMES ROBERTSON: Eastern scene, probably Constantinople, 1850's

67. FRANCIS BEDFORD: Corfu, February 24th, 1862

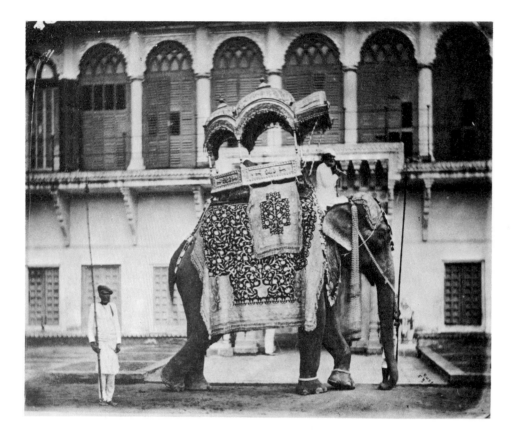

68. Rust: The State Elephant of a Benares Rajah

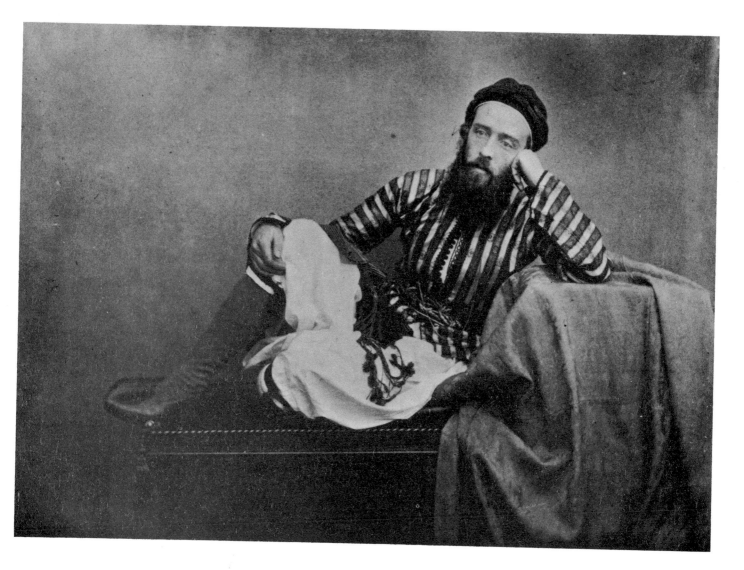

69. Francis Frith: Self-portrait in eastern dress

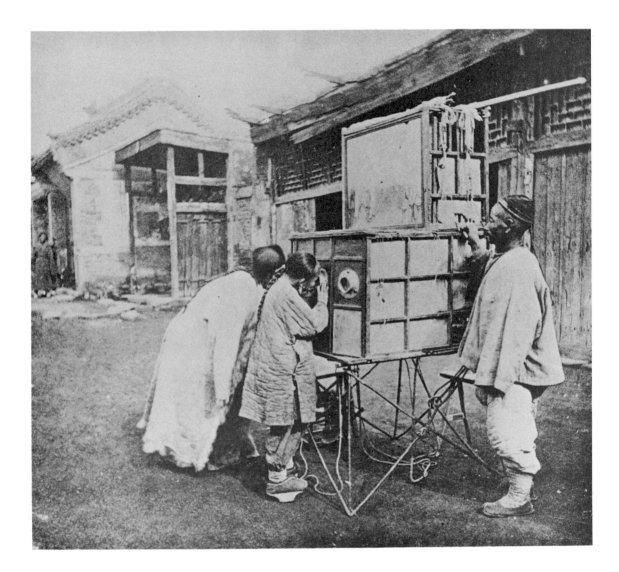

70. JOHN THOMSON: The Peepshow, China, 1873

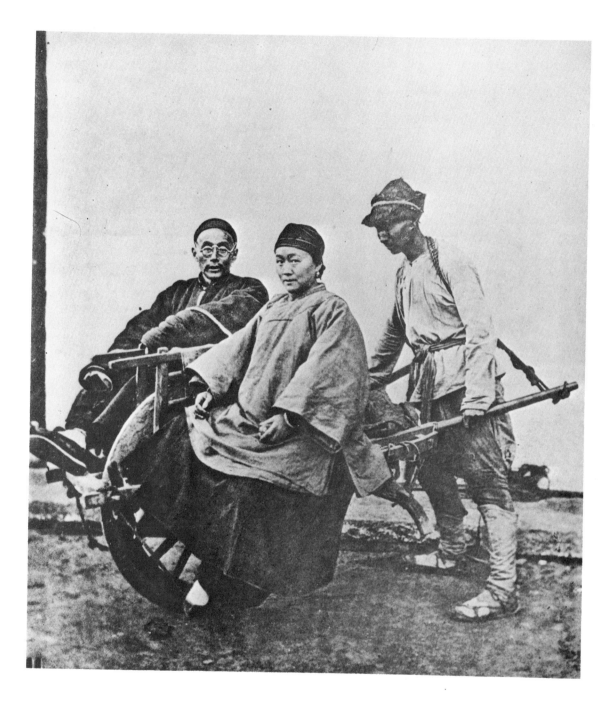

71. John Thomson: The Rickshaw, China, 1873

72. SAMUEL BOURNE: Snow in Upper Burma

73. Felice A. Beato: River Scene, India

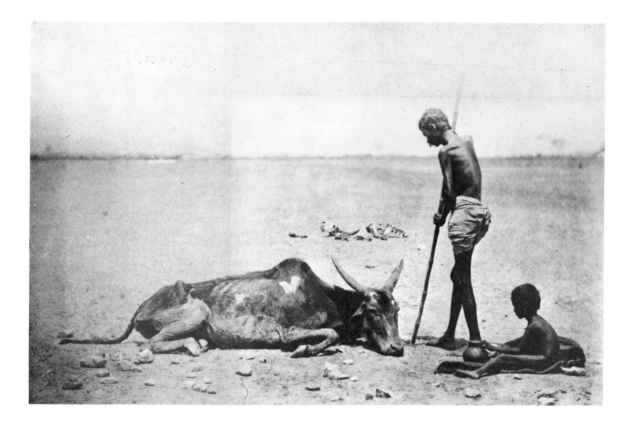

74. W. W. HOOPER: "The last of the herd"—Madras famine, 1876–8

75. W. W. Hooper: Indian Girl, 1870–80

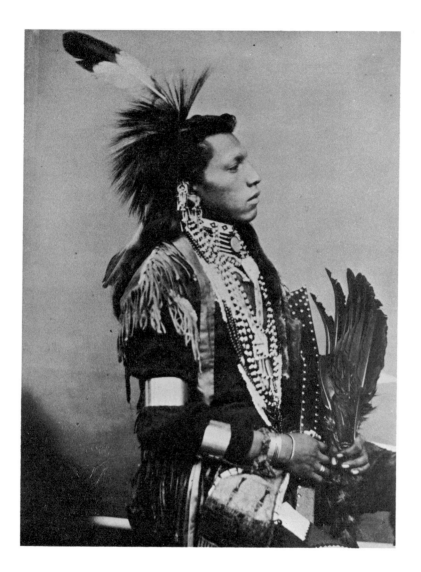

76. ANONYMOUS: Photograph of an American Indian made for Prince Roland Bonaparte

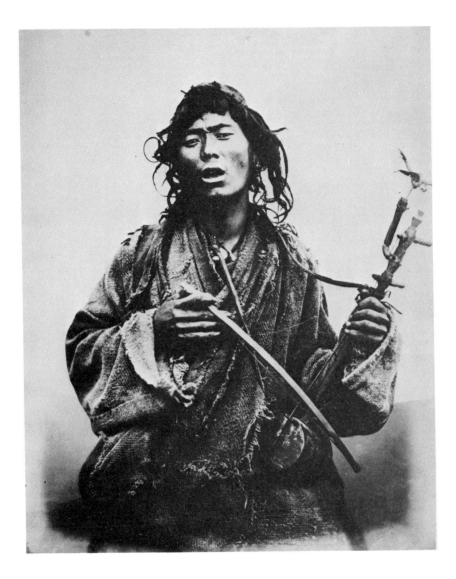

77. ANONYMOUS: A Tibetan Musician, c. 1870

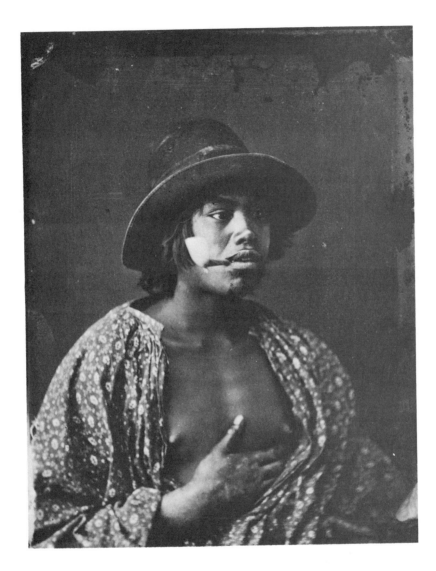

78. THE AMERICAN PHOTO COMPANY: Maori woman smoking a pipe, c. 1865

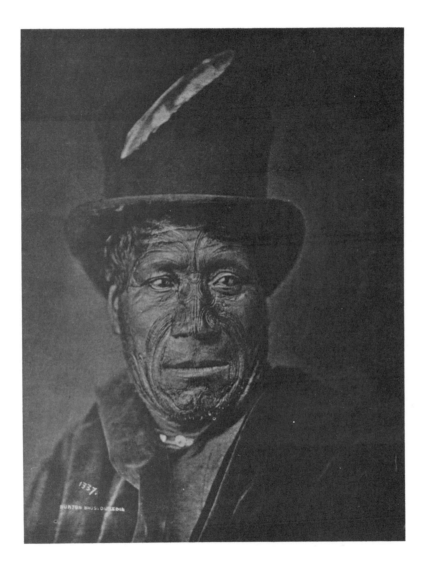

79. ALFRED H. BURTON: Maori man, with tall hat and feather, c. 1878

80. JAMES BRAGGE: New Zealand landscape, c. 1875

81. FELICE A. BEATO: River scene in Japan, 1862

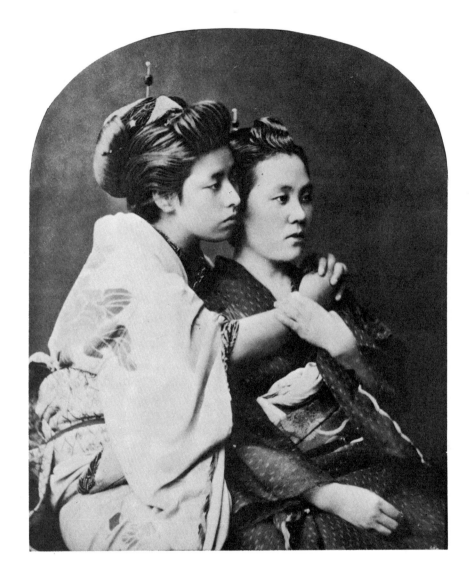

82. STILLFIELD and ANDERSON, YOKOHAMA: Japanese Girls, c. 1900

83. THE NATAL STEREO AND PHOTOGRAPHIC COMPANY, PIETERMARITZBURG: The Pioneer, 1880's

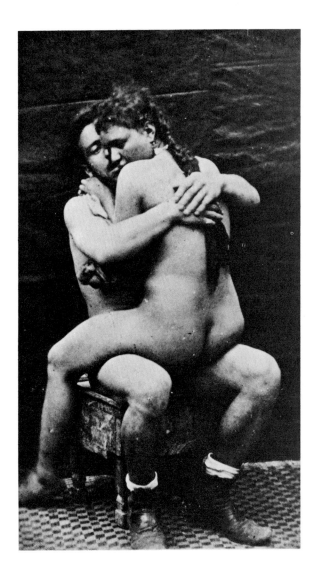

84. ANONYMOUS: Erotic carte de visite, India, c. 1865

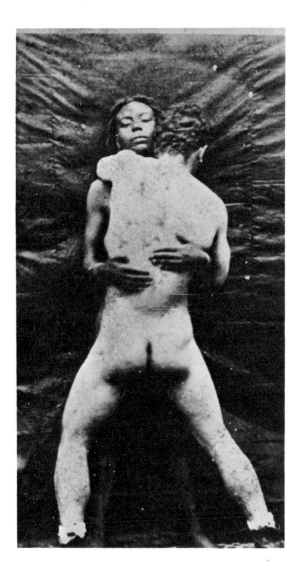

85. Anonymous: Erotic carte de visite, India, c. 1865

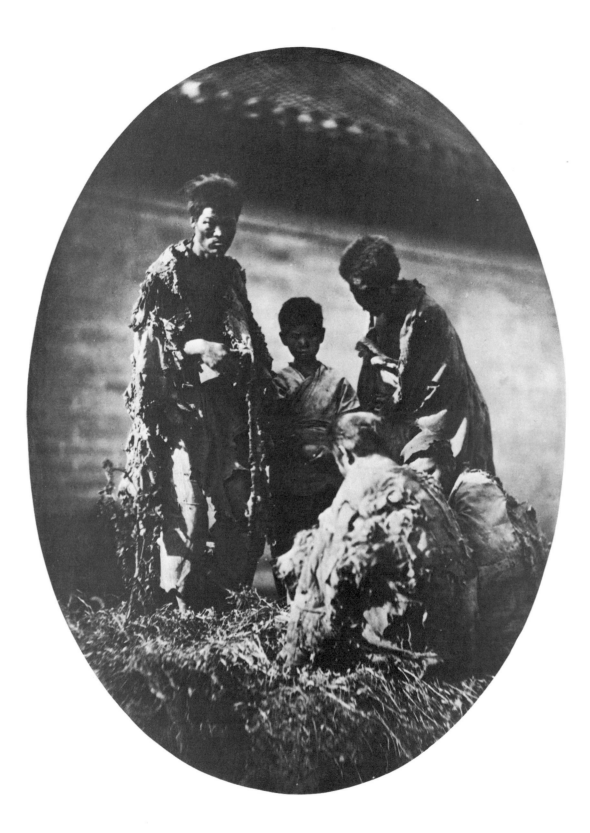

86. ANONYMOUS: Peking beggars in full dress, 1880's

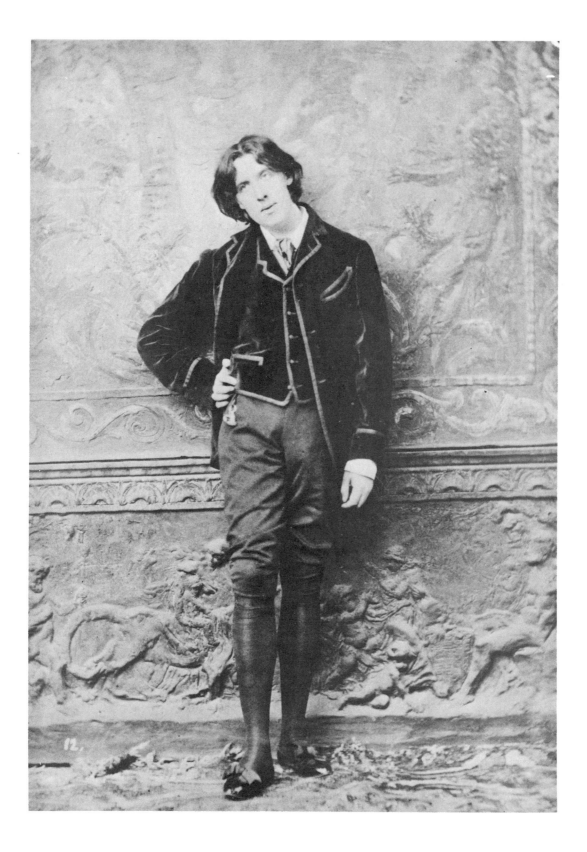

87. NAPOLEON SARONY: Oscar Wilde, 1882

88. EADWEARD MUYBRIDGE: Volcano Quetzaltenango, Guatemala, 1875

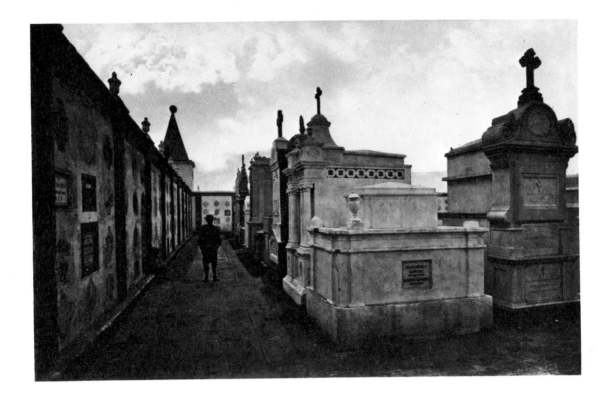

89. EADWEARD MUYBRIDGE: Cemetery, City of Guatemala, 1875

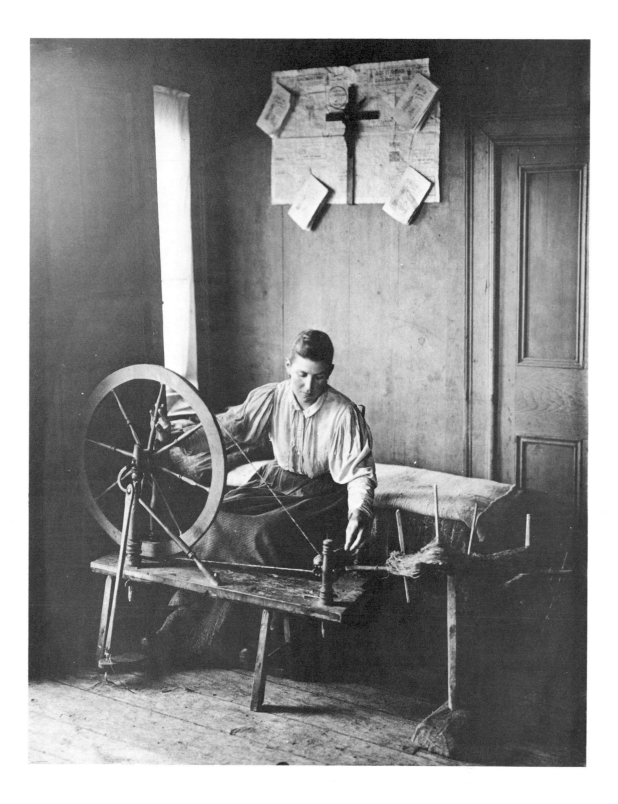

90. NOTMAN STUDIOS: Spinning at Cap a l'Aigle

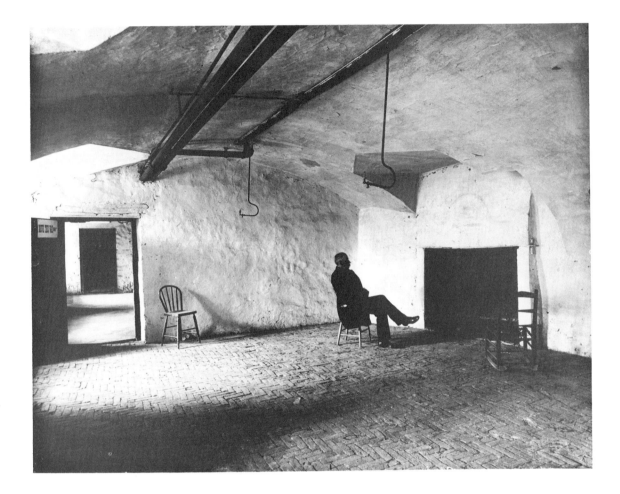

91. Notman Studios: Bake-oven, Château de Ramezay, Montreal

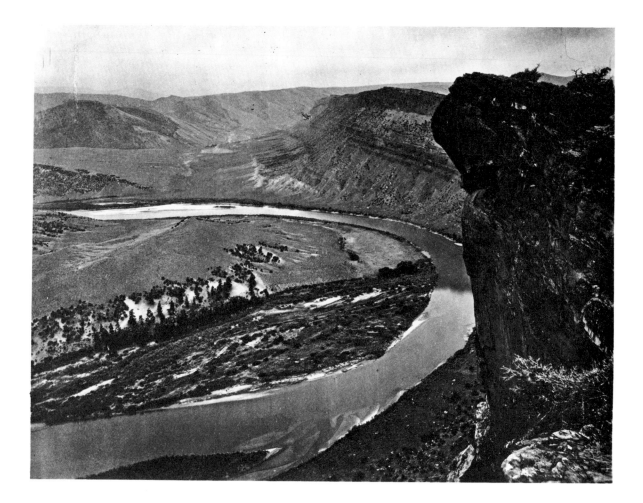

92. T. H. O'Sullivan: Green River near Flaming Gorge, 1869 or 1872

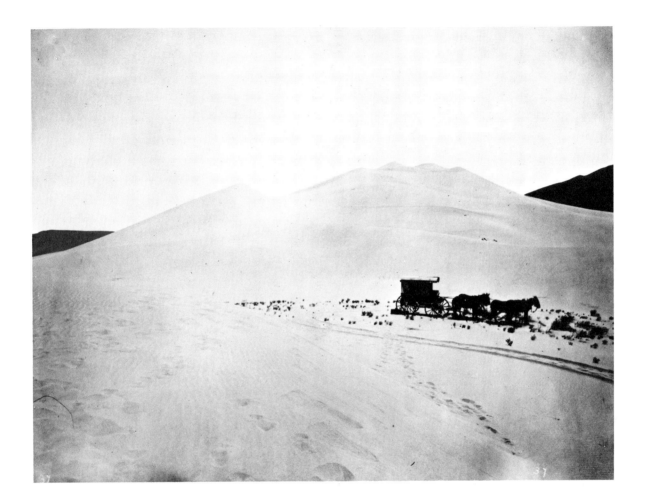

93. T. H. O'SULLIVAN: Sand Dunes near Sand Springs, Nevada, 1869

94. GEORGE H. BARKER: Dixon crossing Niagara on a 7/8 inch wire, 1880's

95. T. H. O'SULLIVAN: The start from Camp Mojave, Arizona, September 15th, 1871

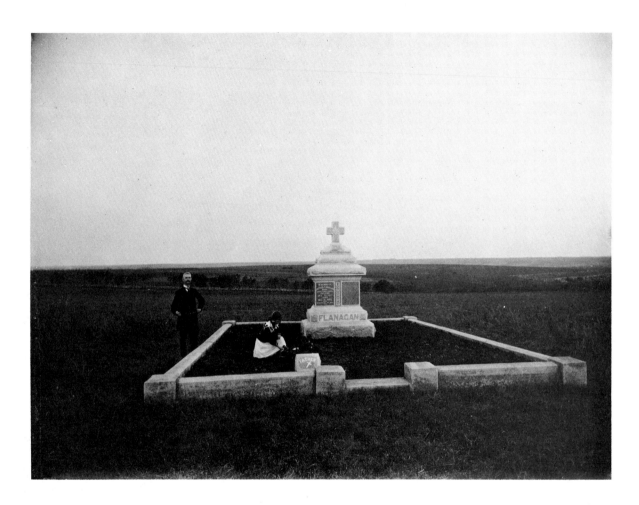

96. J. J. Pennell: A Grave in Kansas, 1908

97. NOTMAN STUDIOS: Ice Palace, Dominion Square, Montreal, 1884

98. George H. Barker: Moonlight on St. John's River, Florida, 1886

99. WILLIAM ENGLAND: Lake Orta, c. 1864

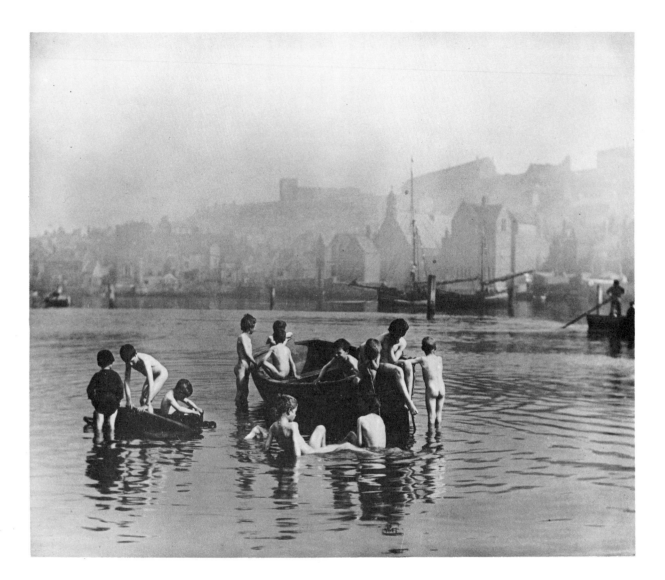

100. Frank M. Sutcliffe: "The Water Rats"

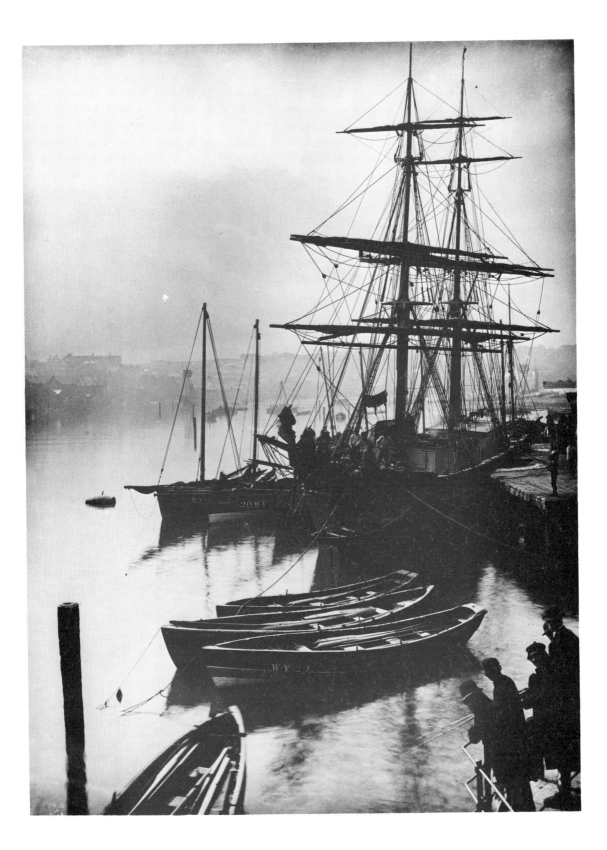

101. FRANK M. SUTCLIFFE: Boats moored against the quayside, Whitby Upper Harbor

102. BELLE JOHNSON: Three girls with long hair

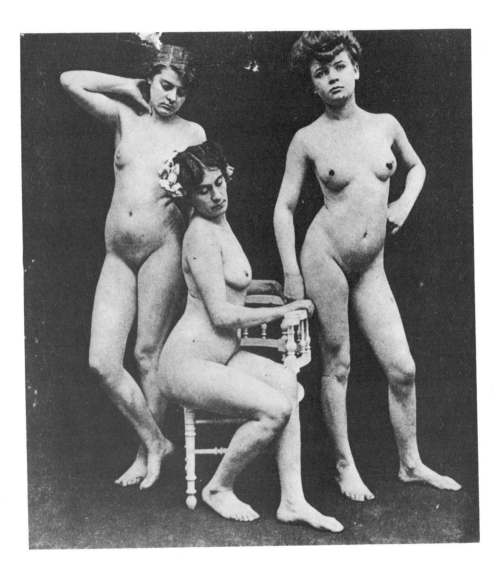

103. ANONYMOUS: Three Nudes, 1880's

104. WILHELM LUKS, VIENNA: The Duchess of Hamilton, c. 1882

105. ᴀɴᴏɴʏᴍᴏᴜs: Captain Webb, the swimmer

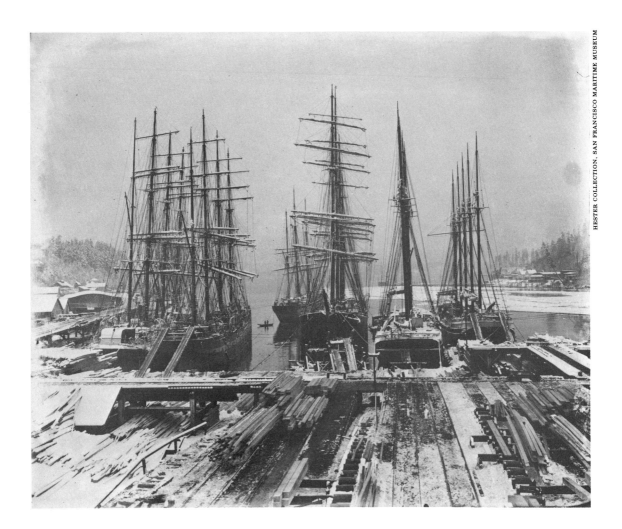

106. WILLIAM HESTER: Loading at Port Blakely, Puget Sound, Washington, Winter 1905

107. FRANCIS FRITH: Oxford—Marston Ford, Mesopotamia, 1912

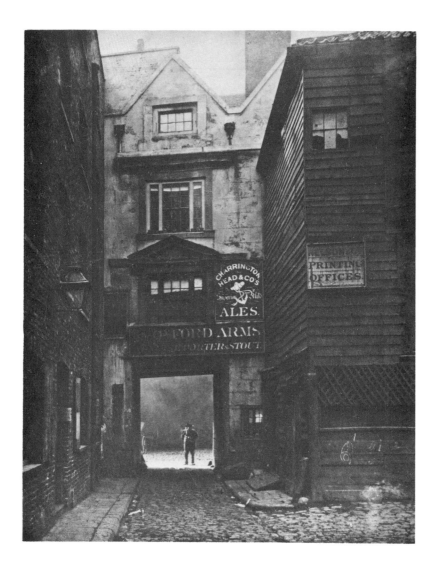

108. A. & J. Boole: The Oxford Arms, London, 1875

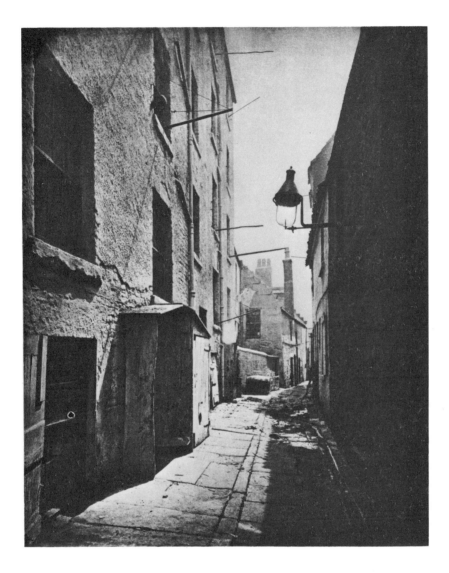

109. T. & R. ANNAN: Close No. 157, Bridgate, Glasgow, 1868

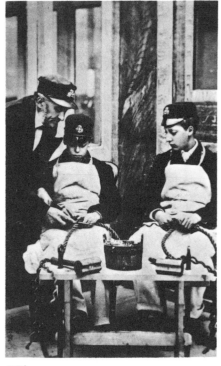

110A

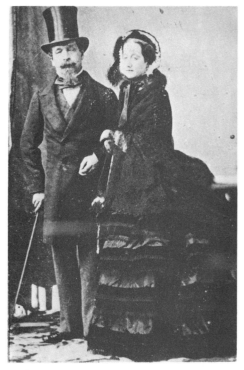

110B

110C

110D

110A. W.&D. Downey: Prince Albert and Prince George abroad the royal yacht "Victoria & Albert," 1860's

110B. Disdéri: Napoleon III and Empress Eugènie, 1860's 110C. Camille Silvy: Lord Dufferin, 1860's

110D. Camille Silvy: The Duchess of Cambridge, 1860's

Mrs Hudson
Abortionist

Mrs Deitze alias Baker
Lifter

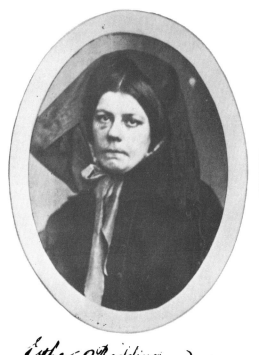

Esther Redding
pick pocket ny

Lavina Adran
Lifter

111. SAMUEL G. SZABO: A page from an American rogue's gallery, c. 1860–70

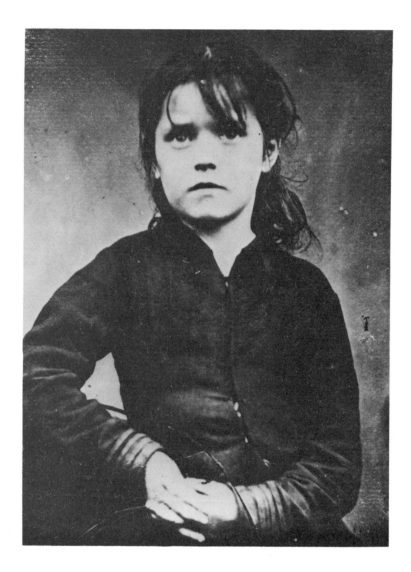

112. Dr. Barnardo's Studio: Sarah Burge, 1883

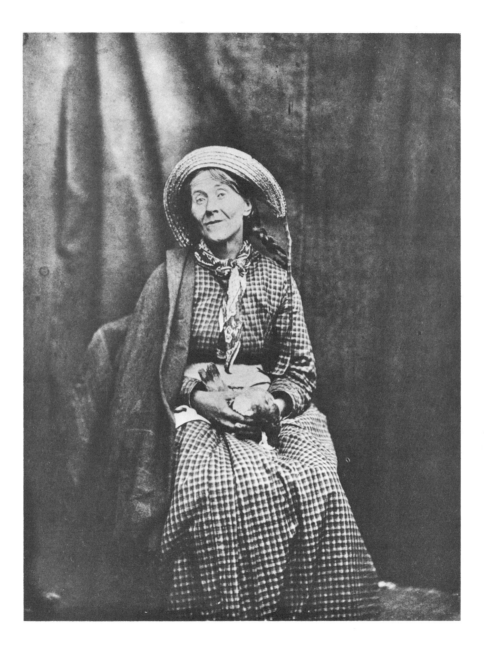

113. HUGH. W. DIAMOND: Mental Patient

114. Arnold Genthe: San Francisco Fire, 1906

133. HENRY TAUNT: Widening Magdalen Bridge, Oxford, 1883

134. FRANCES B. JOHNSTON: Hampton Institute—stairway of Treasurer's residence, students at work, 1899–1900

135. FRANCES B. JOHNSTON: Hampton Institute—Geography, studying the cathedral towns, 1899–1900

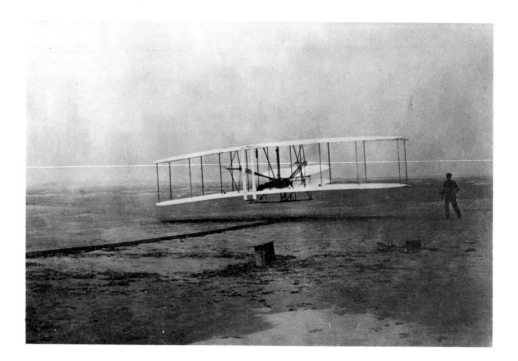

136. JOHN T. DANIELS: Orville Wright taking off, December 17th, 1903

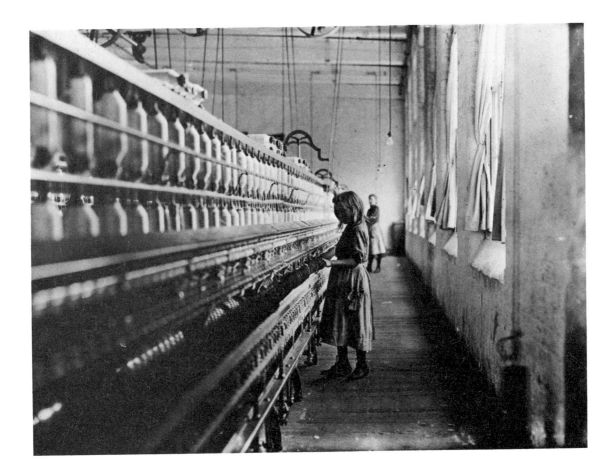

137. Lewis Hine: Carolina Cotton Mill, 1908

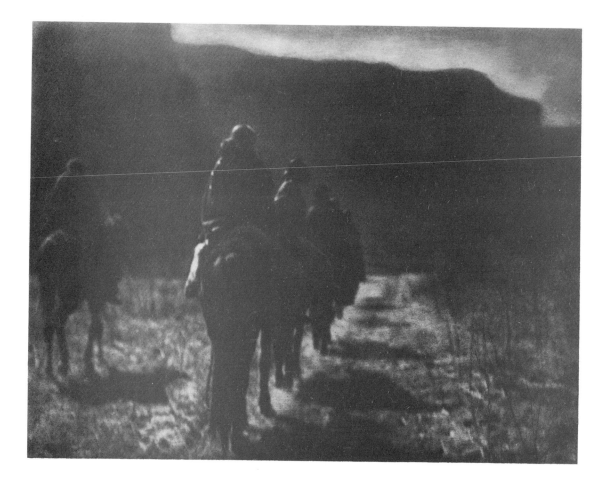

138. EDWARD S. CURTIS: The Vanishing Race—Navaho, 1904

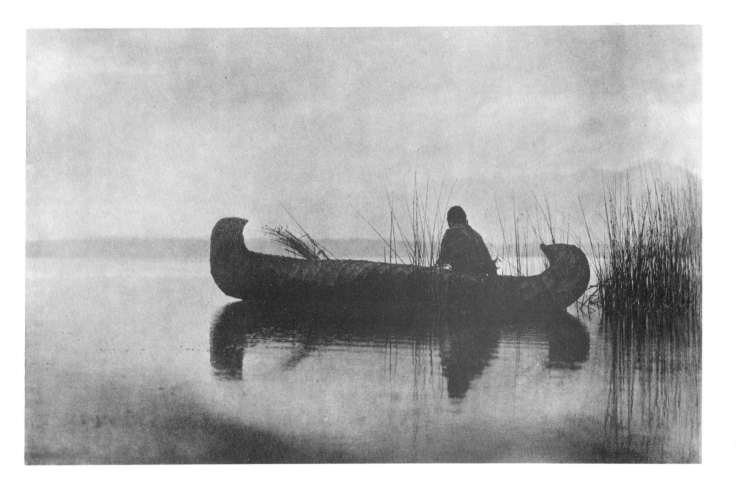

139. Edward S. Curtis: Kutenai Duck Hunter, 1910

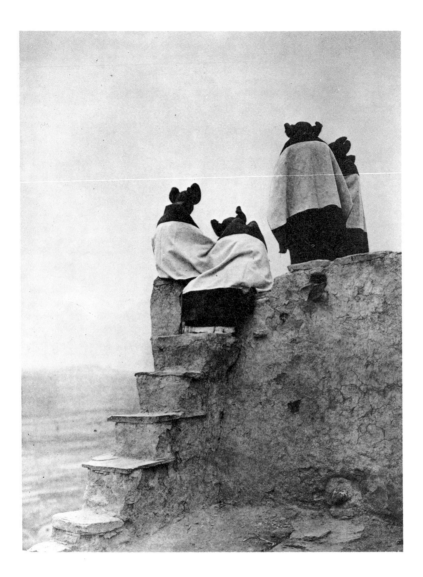

140. Edward S. Curtis: Watching the Dancers—Hopi, 1906

141. FREDERICK H. EVANS: The Sea of Steps, Wells Cathedral, 1903

142. FREDERICK H. EVANS: Château Montesqieu, c. 1900

143. Frederick H. Evans: In Redlands Woods, Surrey, c. 1900

144. ALVIN LANGDON COBURN: Auguste Rodin, 1906

145. F. HOLLAND DAY: Study for the Crucifixion, c. 1898

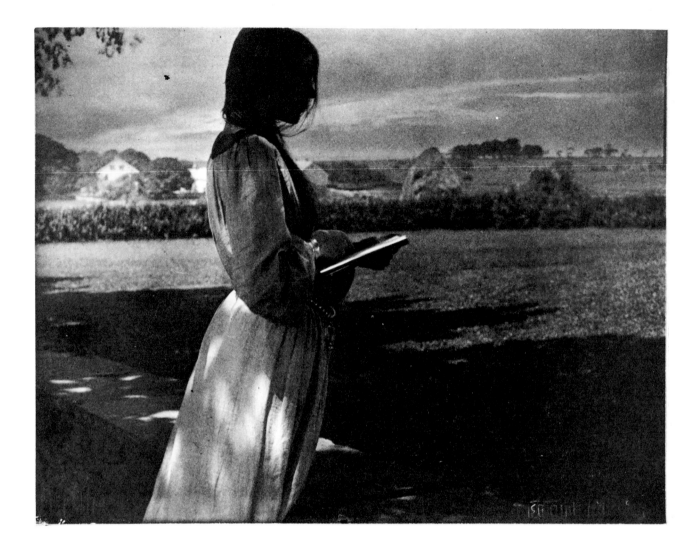

146. Gertrude Käsebier: The Sketch, 1902

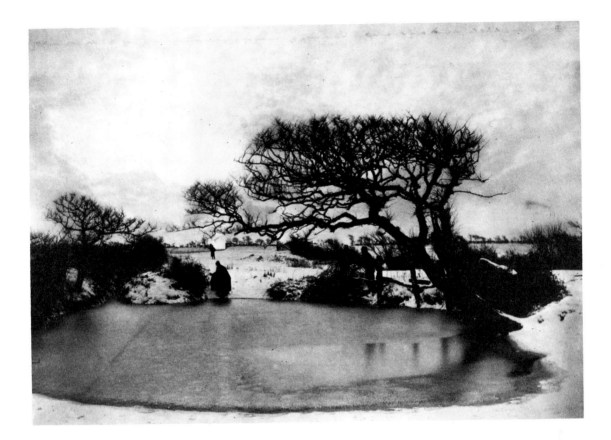

147. P. H. Emerson: A Pond in Winter

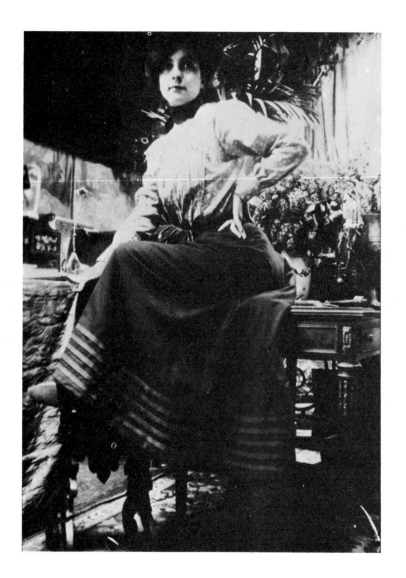

148. ALPHONSE MUCHA: Study for the poster for the Paris "Exposition Universelle," 1900

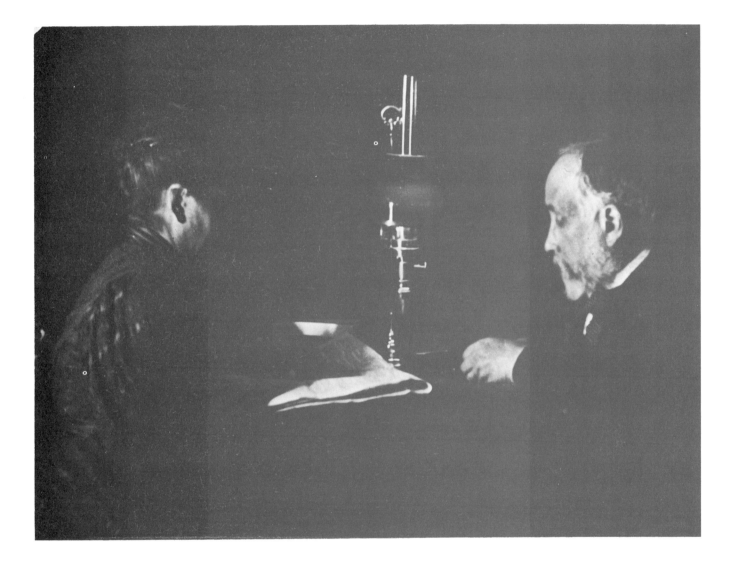

149. EDGAR DEGAS: Self-portrait with Mme Halévy, c. 1895

150. H. WALTER BARNETT: Sarah Bernhardt

151. FREDERICK HOLLYER: Mrs. Patrick Campbell

152. Eugène Atget: Corset Shop, Paris, c. 1908

153. Eugène Atget: Car-Repairer's Workshop, Paris, 1900's

154. HEINRICH ZILLE: Poor women dragging a cart full of brushwood at Charlottenburg

155. ALFRED STIEGLITZ: The Steerage, 1907

156. CARL BORNTRAEGER: Wiesbaden, man in a studio mock-up of a railway carriage, 1860s

Index of Contributing Photographers

Plate numbers of photographs are in italics.

PICTURE CREDITS

Author's collection; 1. George Eastman House; 2. Gernsheim Collection, University of Texas at Austin; 3. George Eastman House; 4. Staatliche Landesbildstelle, Hamburg; 5. Gernsheim Collection, University of Texas; 6. Museum of Fine Arts, Boston; 7. Gernsheim Collection, University of Texas; 8. Science Museum, London; 9. Science Museum, London; 10. Science Museum, London; 11. National Galleries of Scotland; 12. National Galleries of Scotland; 13. National Galleries of Scotland; 14. Edinburgh Central Public Library; 15. The Morris L. Parrish Collection of Victorian Novelists, Princeton University Library; 16. Gernsheim Collection, University of Texas; 17. The Morris L. Parrish Collection of Victorian Novelists, Princeton University Library; 18. Sotheby's Belgravia; 19. Royal Photographic Society; 20. Royal Photographic Society; 21. Gernsheim Collection, University of Texas; 22. Victoria and Albert Museum; 23. Victoria and Albert Museum; 24. Sotheby's, Belgravia; 25. Sotheby's, Belgravia; 26. Sotheby's, Belgravia; 27. Sotheby's, Belgravia; 28. Bibliothéque Nationale, Paris; 29. Bibliothéque Nationale, Paris; 30. Victoria and Albert Museum; 31. Bibliothéque Nationale, Paris; 32. Private Collection; 33. Bibliothéque Nationale, Paris; 34. Bibliothéque Nationale, Paris; 35. Royal Library, Windsor Castle; 36. Victoria and Albert Museum; 37. Victoria and Albert Museum; 38. George Eastman House; 39. André Jammes, Paris; 40. Victoria and Albert Museum; 41. Victoria and Albert Museum; 42. Royal Library, Windsor Castle; 43. Gernsheim Collection, University of Texas; 44. Royal Photographic Society; 45. Gernsheim Collection, University of Texas; 46. Victoria and Albert Museum; 47. Victoria and Albert Museum; 48. Victoria and Albert Museum; 49. The Metropolitan Museum; 50. The Metropolitan Museum; 51. The Metropolitan Museum; 52. Library of Congress; 53. National Archives, Brady Collection; 54. Library of Congress; 55. Library of Congress; 56. Christie, Manson & Woods; 57. Christie, Manson & Woods; 58. Sotheby's, Belgravia; 59. Sotheby's, Belgravia; 60. George Eastman House; 61. Notman Archives, McCord Museum; 62. George Eastman House; 63. Sotheby's, Belgravia; 64. The Sir Benjamin Stone Collection of Photographs in the Birmingham Public Libraries; 65. National Portrait Gallery, London; 66. Sotheby's, Belgravia; 67. Howard Ricketts Ltd; 68. Sotheby's, Belgravia; 69. Sotheby's, Belgravia; 70. Private Collection; 71. Private Collection; 72. Victoria and Albert Museum; 73. Victoria and Albert Museum; 74. Royal Geographical Society; 75. Sotheby's, Belgravia; 76. Private Collection; 77. Royal Geographical Society; 78. National Museum, Wellington, NZ; 79. National Museum, Wellington, NZ; 80. National Museum, Wellington, NZ; 81. Howard Ricketts Ltd.; 82. Sotheby's, Belgravia; 83. John Hall and David McWilliams; 84. Private collection; 85. Private Collection; 86. Private Collection; 87. George Eastman House; 88. Rare Books and Special Collections, Stanford University Libraries; 89. Rare Books and Special Collections, Stanford University Libraries; 90. Notman Photographic Archives, McCord Museum; 91. Notman Photographic Archives, McCord Museum; 92. Library of Congress; 93. George Eastman House; 94. George Eastman House; 95. George Eastman House; 96. Kansas Collection, University of Kansas Libraries; 97. Notman Photographic Archives, McCord Museum, McGill University; 98. Library of Congress; 99. Gernsheim Collection, University of Texas; 100. The Sutcliffe Gallery; 101. The Sutcliffe Gallery; 102. The Massillion Museum; 103. Kasmin Collection; 104. Hall and McWilliams; 105. Hall and McWilliams; 107. The Rothaman Collection of Victorian Photographs by Francis Frith; 108. Sotheby's, Belgravia; 109. Sotheby's, Belgravia; 110A. Hall and McWilliams; 110B. Victoria and Albert Museum; 110C. Victoria and Albert Museum; 110D. Victoria and Albert Museum; 111. Christie, Manson & Woods; 112. Barnardo Photo Library; 113. Royal Society of Medicine; 114. The California Palace of the Legion of Honor; 115. Museum of Modern Art, NY; 116. Sotheby's, Belgravia; 117. Sotheby's, Belgravia; 118. Gernsheim Collection, University of Texas; 119. Private collection; 120. Sotheby's, Belgravia; 121. Jacob A. Riis Collection, Museum of the City of New York; 122. The Jacob A. Riis Collection, Museum of the City of New York; 123. Liverpool Public Libraries; 124. George Eastman House; 125. George Eastman House; 126. Victoria and Albert Museum; 127. Anthony d'Offay Ltd.; 128. The photographer; 129. The photographer; 130. Hereford City Library; 131. The Trustees of the Hornel Trust, Broughton House, Kirkcudbright; 132. The Vick Collection, Ipswich and East Suffolk Record Office; 133. Oxford City Library; 134. Museum of Modern Art, New York; 135. Museum of Modern Art, NY; 136. Library of Congress; 137. George Eastman House; 138. The Philadelphia Museum of Art, purchased with funds from the American Museum of Photography; 139. The Philadelphia Museum of Art etc.; 140. The Philadelphia Museum of Art etc.; 141. 142. Howard Ricketts Ltd; 143. Sotheby's, Belgravia; 144. Sotheby's, Belgravia; 145. The Metropolitan Museum, Alfred Stieglitz Collection; 146. George Eastman House; 147. George Eastman House; 148. Sotheby's, Belgravia; 149. The Metropolitan Museum; 150. Victoria and Albert Museum; 151. Victoria and Albert Museum; 152. Macmillan & Co. Inc.; 153. Macmillan & Co. Inc., NY; 154. Fackelträger-Verlag, Hanover; 155. Museum of Modern Art, NY; 156. Hall and McWilliams.

Selected Bibliography

Abbott, Bernice. *The World of Atget*. New York, 1964.

Aperture Inc., *French Primitive Photography*. Aperture, Vol. 15 No. 1, Spring 1970.

The Arts Council of Great Britain, *"From today painting is dead"*—catalogue of an exhibition held at the Victoria & Albert Museum, London, 16 March–16 May, 1972. London, 1972.

Baynes, Ken, Tom Hopkinson, Allen Holt, Derrick Knight. *Scoop, Scandal and Strife*. London, 1971.

Bellocq, E. J. *Storyville Portraits*. New York, 1970.

Braive, Michel F. *The Era of the Photograph*. London, 1965.

Bry, Doris. *Alfred Stieglitz, Photographer*. Boston, 1965.

Coburn, Alvin Langdon. *An Autobiography*, ed. Helmut and Alison Gernsheim. London, 1966.

Belous, Russell E., and Robert A. Weinstein, *Will Soule, Indian Photographer*. Los Angeles, 1969.

Bruce, David. *Sun Pictures: The Hill/Adamson Calotypes*. London, 1973.

Burke, Keast. *Gold and Silver*. Melbourne, Australia, 1973.

Chandler, George. *Victorian and Edwardian Liverpool and the North West from Old Photographs*. London, 1972.

Collins, Leonora. *London in the Nineties*. London, 1950.

Curtis, Edward S. *The North American Indians*. New York, 1972.

Gardner, Alexander. *Gardner's Photographic Sketchbook of the Civil War*. New York, 1959 (a reprint of the first ed. of 1866).

Gernsheim, Helmut, and Alison Gernsheim, *Roger Fenton: Photographer of the Crimean War*. London, 1954.

— — *The History of Photography*. London, 1955. *L. J. M. Daguerre*. 2nd revised ed., New York, 1968.

Gernsheim, Helmut. *Masterpieces of Victorian Photography*. London, 1951.

— — *Lewis Carroll, Photographer*. New York, 1969 (reprint of the first edition, London 1949).

Gorham, Maurice. *Dublin from Old Photographs*. London, 1972.

Govett-Brewster Art Gallery, *Nineteenth Century New Zealand Photographs*, ed. John B. Turner. New Plymouth, New Zealand, 1970.

Graham, Malcolm. *Henry Taunt of Oxford*. Risinghurst, Oxford, 1973.

Grey, Howard, and Graham Stuart. *The Victorians by the Sea*. London, 1973.

Harper, J. Russell. *Portrait of a Period: A Collection of Notman Photographs 1856–1915*. Toronto, 1967.

Harrison, Colin. *Victorian and Edwardian Suffolk from Old Photographs*. London, 1973.

Hendricks, Gordon. *The Photographs of Thomas Eakins*. New York, 1972.

Hill, Brian. *Julia Margaret Cameron*. London, 1973.

Horan, James D. *Mathew Brady*. New York, 1955.

Hubmann, Franz. *Dream of Empire*. London, 1973.

Jammes, André. *Charles Nègre, Photographe*. Paris, 1963.

— — *William H. Fox Talbot*. Lucerne, 1972.

Jay, Bill. *Customs and Faces: Photographs by Sir Benjamin Stone*. London, 1972.

— — *Victorian Candid Camera*. Newton Abbot, Devon, 1973.

— — *Victorian Cameraman: Francis Frith's Views of Rural England*. Newton Abbot, Devon, 1973.

Jensen, Oliver, Joan Paterson Kerr and Murray Belsky. *American Album*. New York, 1968.

Jones, Edgar Yoxall. *O. G. Rejlander: Father of Art Photography*. Newton Abbot, Devon, 1973.

Kirstein, Lincoln. *The Hampton Album.* New York, 1966.

Lartigue, Jean Henri. *Boyhood Photos of J. H. Lartigue.* Lausanne, 1966.

MacDonnell, Kevin. *Eadweard Muybridge.* London, 1972.

Mathews, Oliver. *Early Photographs and Early Photographers.* London, 1973.

Metropolitan Museum of Art, N.Y., *The Painterly Photograph 1890–1914.* New York, 1973.

Minto, C. S. *Victorian and Edwardian Scotland from Old Photographs.* London, 1970.

Moretti, Lino. *Vecchie Immagine di Venezia.* Venice, 1972.

Muybridge, Eadweard. *The Human Figure in Motion.* New York, 1955. (a selection from the plates in *Animal Locomotion,* pub. 1887).

The National Portrait Gallery, London, *Sir Benjamin Stone.* London, 1974.

— — *The Hill/Adamson Albums.* London, 1972.

— — *The Camera and Dr. Barnardo.* London, 1974.

Newhall, Beaumont. *The History of Photography.* Revised ed., London, 1972.

— — *Frederick H. Evans.* New York, 1973.

Newhall, Beaumont, and Nancy Newhall, *T. H. O'Sullivan, Photographer.* Rochester, New York, 1966.

Ovenden, Graham. *Pre-Raphaelite Photography.* London, 1972.

Ovenden, Graham, and Robert Melville, *Victorian Children.* London, 1972.

Ovenden, Graham, and Peter Mendes. *Victorian Erotic Photography.* London, 1973.

Paris: Musée des Arts Decoratifs, *Un Siècle de Photographie: de Niepce à Man Ray.* Paris, 1965.

Phillips, David R. *The West.* Chicago, 1973.

Pollack, Peter. *The Picture History of Photography.* Revised ed., New York, 1969.

Pritchard, H. Baden. *About Photography and Photographers.* New York, 1973. (first published in 1883).

Proust. Marcel. *A Vision of Paris* (illustrated with photographs by Atget). New York, 1963.

Riis, Jacob A. *How the Other Half Lives.* New York, 1971.

Rome: Amici de Musei di Roma, *Mostra della Fotografia a Roma dal 1840 al 1915.* Rome, 1956.

Scharf, Aaron. *Art and Photography.* London, 1968.

Shaw, Bill Eglon. *Frank Meadow Sutcliffe, Photographer.* Whitby, Yorks, 1974.

Stanford University, *Eadweard Muybridge, The Stanford Years.* Palo Alto, 1972.

Strassner, Alex. *Immortal Portraits.* London and New York, 1941.

Szarkowski, John (ed.). *The Photographer and the American Landscape.* New York, 1963.

Szarkowski, John. *Looking at Photographs.* New York, 1973.

Taft, Robert. *Photography and the American Scene.* New York, 1964. (reprint of 1938 ed.)

Time Inc., *Great Photographers.* New York, 1971/73.

Tucker, Anne. *The Woman's Eye.* New York, 1973.

Vitali, Lamberto. *Un fotografo fin de siècle: Il conte Primoli.* Turin, 1968.

Washington, D.C.: Library of Congress, *Image of America.* Washington, 1967.

Werge, John. *The Evolution of Photography.* New York, 1973. (reprint of first ed. of 1890).

Winter, Gordon. *A Country Camera, 1844–1914.* Newton Abbot, Devon, 1971.

Woolf, Virginia, and Roger Fry, (ed. Tristram Powell). *Victorian Photographs of Famous Men and Fair Women by Julia Margaret Cameron.* London, 1973.